Understanding
HDR
Photography

THE EXPANDED GUIDE

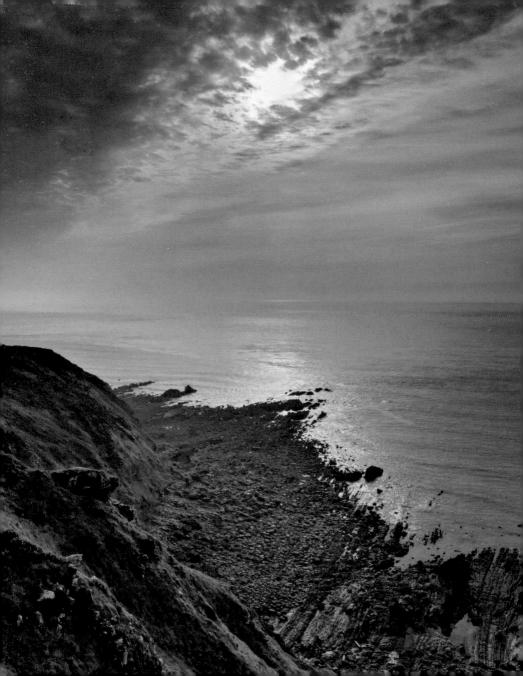

Understanding
HDR
Photography

THE EXPANDED GUIDE

David Taylor

AMMONITE
PRESS

First published 2012 by
Ammonite Press
an imprint of AE Publications Ltd
166 High Street, Lewes, East Sussex, BN7 1XU, United Kingdom

Text © AE Publications Ltd, 2012
Photography © David Taylor, 2012
Copyright © in the work AE Publications Ltd, 2012

ISBN 978-1-90770-854-1

Editor: Chris Gatcum
Series Editor: Richard Wiles
Design: Richard Dewing Associates

Typeset in Frutiger
Color reproduction by GMC Reprographics
Printed and bound in China by Leo Paper Group

(Page 2)
Sunset over Hartland Point,
North Devon, United Kingdom.

CONTENTS

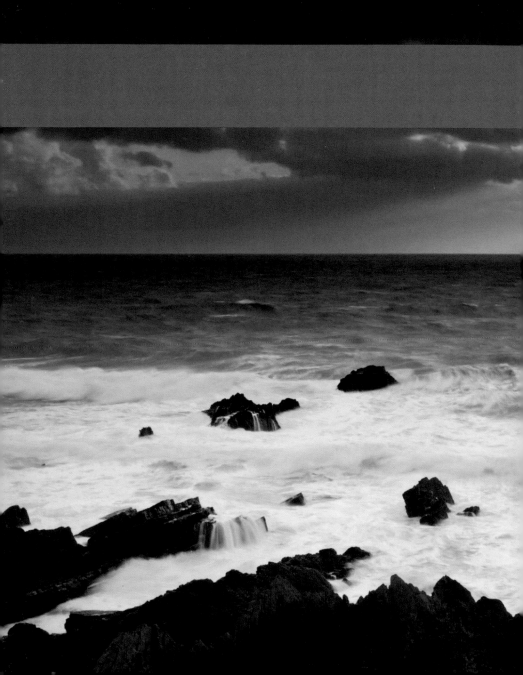

CHAPTER 1 INTRODUCTION

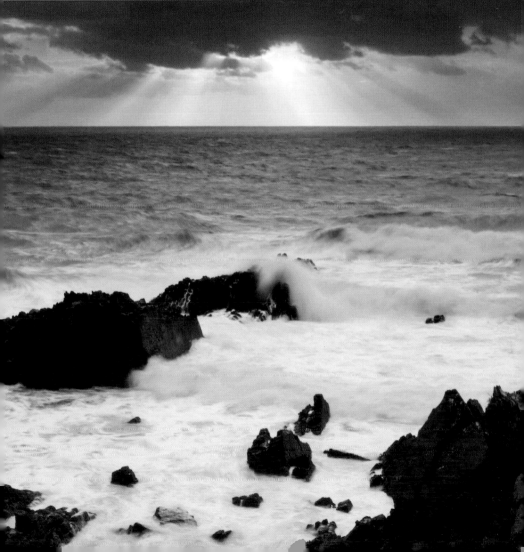

HDR photography

Get two photographers together and for fun ask them to discuss the merits—or otherwise—of HDR photography. Sparks will truly fly if there is a difference of views, because HDR (High Dynamic Range) imaging is a photographic technique that sharply divides opinion.

Nothing new under the sun

There is no such thing as the perfect camera, nor will there ever be. Part of the problem is that cameras compete with an astonishingly versatile instrument: the human eye. We can see a range of light levels and colors that no man-made object could ever hope to replicate. HDR is a technique that offers one solution to capturing the world in a way that an off-the-shelf camera normally couldn't.

Although HDR, as we know it, relies on digital technology, photographers have been trying to find solutions to the inadequacies of cameras since they were first invented. Some of these techniques involved shooting multiple images of a scene and combining them in the darkroom in an analogous way to how HDR images are created in the digital "lightroom." Other techniques involve the use of filters or multiple exposures onto the same piece of film.

This book is a guide to beginning your journey into HDR photography, exploring how to shoot for HDR and how to use some of the most popular HDR software. It is also a guide to some of the "old-fashioned" techniques that are still valid today, even with modern digital cameras. First, however, we will delve into some of the concepts that it is useful to understand before your HDR journey even begins.

DOME
HDR can be used as subtly or as artistically as you wish. This image was created with an eye to producing a photorealistic result.

Canon EOS 70 with 70–200mm lens (at 70mm), three blended images at f/14, ISO 100

FLOWERS *(Opposite)*
HDR can also be used to create images that appear "hyper-real," with a delicacy of light and shadow that is usually only achievable by spending hours setting up lights and reflectors.

Canon EOS 7D with 17–40mm lens (at 40mm), three blended images at f/10, ISO 100

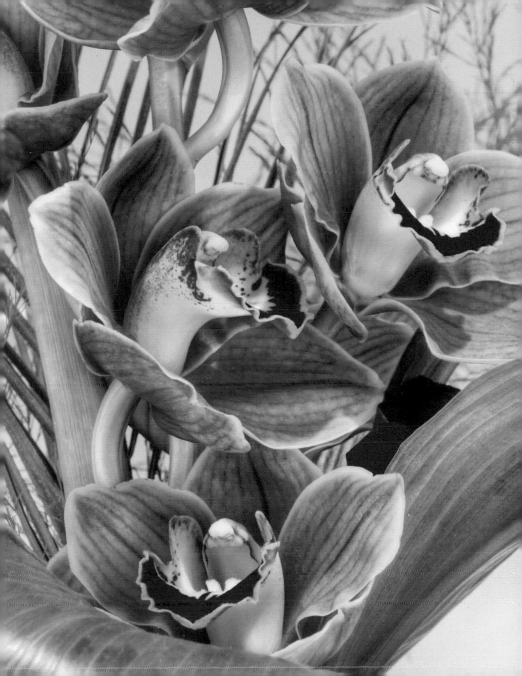

What is HDR photography?

HDR stands for High Dynamic Range. Dynamic range differs from camera model to camera model and it's only with experimentation that you will discover the limits of your own camera.

Dynamic range

A digital camera is a low dynamic range device. That is, it can only record a limited range of brightness (or luminance) levels successfully before either the darkest part of an image is rendered as pure black or the brightest part as pure white. If a scene is relatively low contrast this is usually not a problem—on overcast days the light is generally soft and there are rarely deep shadows or bright highlights, for example.

However, if a scene has more contrast there is often a need to make a compromise in the exposure settings used. You would either set the exposure to record the highlights successfully (but not the shadows), or vice versa. Landscape photographers commonly use graduated filters to increase the apparent dynamic range of an image by effectively using the filter to match the exposure of a bright section of a scene to a darker area. But graduate filters aren't suitable if the brightness levels vary inconsistently across the whole of a scene, in which case HDR imaging can be used.

HDR photography is the technique of shooting a series of different exposures of a scene to record a full range of brightness levels. These exposures are then combined in software to create a composite image that encompasses the brightness range of the series. Typically, three exposures are created, although a very high contrast scene may benefit from five or more frames to cover the dynamic range.

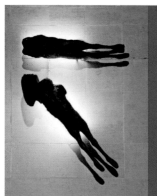

HIGH CONTRAST
This backlit sculpture is a good example of a high-contrast scene, where the sculptures are far darker than the illumination behind them. I wasn't able to record detail in the sculptures when I set the exposure to record the lighting correctly (and vice versa) because the scene exceeded the dynamic range of my camera.

BLENDED *(Opposite)*
By combining two exposures—one for the sculptures and one for the lighting—I was able to create an HDR image that matches more closely how I saw the scene.

Canon EOS 1Ds MkII with 70–200mm lens (at 100mm), two blended exposures at f/14, ISO 100

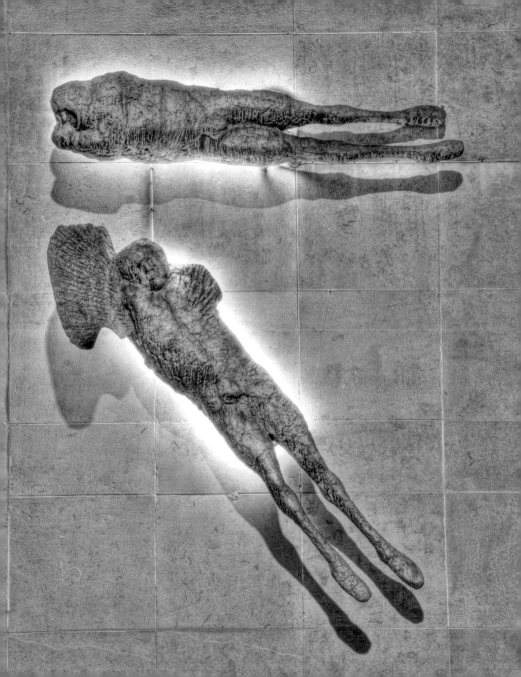

Camera sensors

Understanding how to create impressive HDR images starts with learning more about the digital sensor inside your camera.

Color

There is a number of technologies that have been used to create digital sensors, the most common of which is the Bayer pattern filter system. Sensors that use a Bayer pattern filter system are divided into an array of millions of tiny photosensors, which are arranged into groups of four. The first of this group of four photosensors is filtered to record the red wavelengths of visible light that fall onto it; the second photosensor is filtered for blue light; and the final two are filtered for green. Once an exposure has been made, the information from this group of individually filtered photosensors is then used to create one full-color pixel in the final image. This process is known as demosaicing.

Catching light

Visible light is composed of packets of energy known as photons. When you press the shutter-release button on your camera to make an exposure, the photosensors begin to "collect" photons while the shutter is open. Once the exposure is complete, the number of photons collected is assessed by each photosensor to create an intensity value.

If no photons are collected by a photosensor, the intensity value is zero. If surrounding photosensors also record no photons, the result will be a black pixel in the image. Conversely, if a group of photosensors is filled with photons, the intensity value is at its maximum, resulting in a white pixel.

Note

The alternative to a Bayer pattern sensor is Foveon's X3 sensor, which uses three layers of photosensors embedded in silicon. As light is absorbed to different depths by the silicon, the red, green, and blue wavelengths are each recorded on one of the three photosensor layers, allowing full-color information to be created at each pixel location without a need for demosaicing. This theoretically increases the resolution of the captured image, although only Sigma is currently using this technology.

Size matters

The larger a photosensor, the more photons it can collect during exposure to light. The common analogy is to think of the photosensor as a bucket, and the photons as water—the larger the bucket (photosensor), the more water (photons) it can hold. In the case of digital photography, this means a larger sensor is able to gather more image information at a pixel level than a smaller photosensor.

Compact digital cameras have far smaller sensors than those found in digital SLRs, for example, which means that the individual photosensors on a compact digital camera's sensor must be made physically smaller in order to match the pixel resolution (total number of pixels) of a digital SLR sensor.

Practically, this has the effect of increasing the noise exhibited by a compact digital camera, reducing its dynamic range, and producing a lower usable ISO range. In many respects, compact digital cameras do not benefit from having a high pixel resolution and sometimes fewer "megapixels" will actually deliver a higher image quality. Some of these limitations of a smaller sensor can be worked around by shooting for HDR, but it is worth noting that the maximum image quality is always going to be achieved by shooting with a camera with a bigger sensor.

Digital information

The smallest unit of information used by computers and digital devices such as cameras

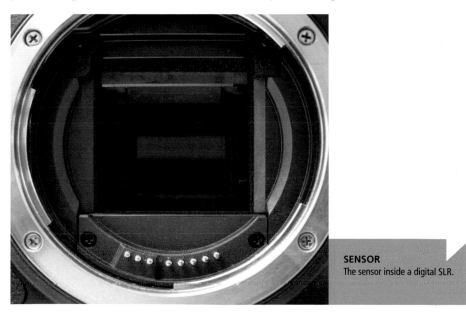

SENSOR
The sensor inside a digital SLR.

is a "bit." A bit is essentially a switch that can be set to "off" or "on": when it is off it records 0, and when it is on it records 1. To switch metaphors, if a bit is a finger the next largest unit of information, the byte, is a hand. A byte is a string of eight bits (or eight fingers to count on if you prefer). Computers use binary notation, so eight bits can be used to store values from 0 to 255 (00000000 to 11111111 in binary code).

There is no such thing as a grayscale monitor, but if there were, you would only need to alter the brightness (or more accurately the luminance) of each pixel in order to display an image. The information for a pixel could then be represented as a numerical value. If this information was stored in a byte, each pixel could have 256 different levels of brightness. So, when the byte is set to 0, a black pixel is displayed and, when set to 255, a white pixel is displayed. A value of 128 equates to mid-gray.

This is essentially how digital image information is displayed, although monitors display a wide range of colors, not just shades of gray. To display a full-color pixel on a monitor, three bytes are used. One byte is used to represent red, another for green, and a third for blue (hence the initials RGB). This results in 16.7 million different possible color combinations when the red, green, and blue values are mixed in different proportions (256 red values x 256 green values x 256 blue values = 16,777,216, or 16.7 million).

RGB
Computers use the additive system to create color, as illustrated below. When the red, green, and blue values are all 255 the result is white, and when they are all 0 the result is black. All other colors are all created by varying the proportions of red, green, and blue.

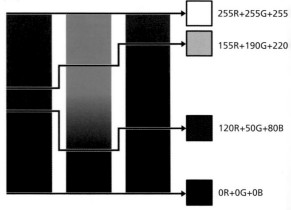

255R+255G+255

155R+190G+220

120R+50G+80B

0R+0G+0B

Bit-depth

You might think that 16.7 million colors is more than enough for your digital photographs, especially as some scientists believe that's about the same number of individual colors that humans can perceive. However, in digital imaging it's not enough by a large margin. If you use one byte to represent a color value, when you make an adjustment that generates a value that is not a whole number (such as 203.5), that number will need to be rounded up or down. Make a number of adjustments and these rounding errors are exacerbated, resulting in an effect known as "posterization," which is seen as a sudden jump or gap between colors in an image.

The solution used by camera manufacturers is to use 12-, 14-, or 16-bits per color channel to record digital images. In a 16-bit image, this means there are 65,536 levels of color per channel (as opposed to 256), resulting in a theoretical 281 trillion different color combinations. There are very few monitors that can display 16-bit color information (and, of course, we would have trouble distinguishing those extra colors ourselves), but this extra color information can be used "behind the scenes," by image-editing software such as Photoshop to avoid posterization.

However, this is nothing compared to HDR images. When you blend images together using HDR software, the image that is produced uses 32-bits per color channel. This means that extensive tonal adjustment can be applied to the image, without the quality deteriorating. The downside is that a 32-bit file takes up an enormous amount of room on a storage device, and there is also relatively little software that supports 32-bit images. Even those packages that do support 32-bit files often place certain restrictions on the number of tools that can be used to make adjustments.

Notes

HDR images actually use floating-point numbers to describe the information in the file. It's not necessary to understand what a floating point number is to use HDR, only that this is a far more efficient way to store the very large image numbers required for 32-bit files.

Because HDR images are 32-bit, your monitor will not be able to display the full range of colors. The image on your screen is only ever an approximation of the tonal range of the HDR file.

Camera: Canon EOS 1Ds MkII
Lens: 17–40mm lens (at 40mm)
Exposure: Three blended images
at f/11
ISO: 100

LIGHT AND SHADOW

HDR really comes into its own when you have a high-contrast scene that exceeds the dynamic range of the camera. This train was strongly backlit, and exposing for the highlights meant losing detail in the shadow. To overcome this, I bracketed three shots and blended them using Photoshop's HDR function.

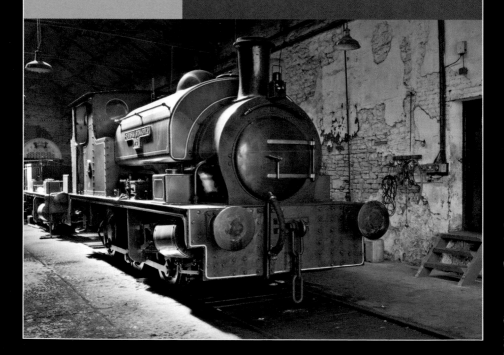

Camera: Canon EOS 1Ds MkII
Lens: 17–40mm lens (at 24mm)
Exposure: Two blended images at f/14
ISO: 100

BEYOND REALITY
If HDR can be seen as a "get out of jail free" option in difficult lighting situations, it can also be used creatively to enhance reality. I visualized this scene as a black-and-white image, and used HDR to increase the tonal range of the rocks to help define the texture.

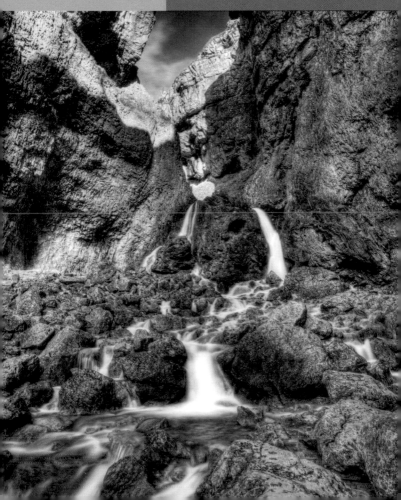

Getting started

Shooting for HDR requires a systematic approach and getting your images right at the moment of exposure will save a lot of time at the post-processing stage.

A disciplined approach

It is possible to create an HDR image from just one source photograph that has been processed with different levels of brightness and saved as three separate files. However, the best results are obtained by using three (or more) source images that have been recorded at different exposure levels. Therefore, part of the discipline of HDR is learning to work consistently.

Using a tripod is highly recommended, as this will help make certain that each image aligns with the others. Although both Photoshop and Photomatix Pro, which are covered later in this book, will attempt to align images during an HDR merge, it's always better to get things right at the start.

Ideally nothing should move in the scene between shots either, as any movement between the source images can cause "ghosting" when an HDR image is created, resulting in odd color shifts or strange blurs. Sometimes this is impossible to achieve, but working as quickly and efficiently as possible will minimize any differences between your source images: even a delay of just a few seconds between shots is enough time for elements such as clouds to move noticeably through the image space. Software such as Photomatix Pro has tools to reduce ghosting, but it is not infallible.

MOVEMENT
Ghosting is visible in this HDR image because the clouds moved while I made the three exposures necessary to create the HDR blend.

Canon EOS 7D with 17–40mm lens (at 36mm), three blended images at f/14, ISO 100

Altering the exposure

Bracketing is the technique of shooting a number of images of a scene and varying the exposure between each shot. Typically one exposure will be "correct," one (or more) will be underexposed, and one (or more) will be overexposed. Bracketing can be achieved manually by using manual exposure or applying exposure compensation, or you can use your camera's auto-exposure bracketing function (usually shortened to AEB).

Using AEB has two advantages. The first is that you do not have to alter any of the camera controls between shots, reducing the risk that your camera will be knocked and therefore moved slightly. The second advantage is that AEB allows you to keep the exposure differences of the bracketed images consistent. Depending on the camera model, automatic exposure bracketing is usually adjustable across a ±3 stop range in ½- or ⅓-stop increments.

The contrast of the scene will determine how much difference you need between your exposures, and how many exposures you need to make, but the simple rule is the higher the

contrast, the wider the exposure range should be (and potentially the greater the number of exposures you will need).

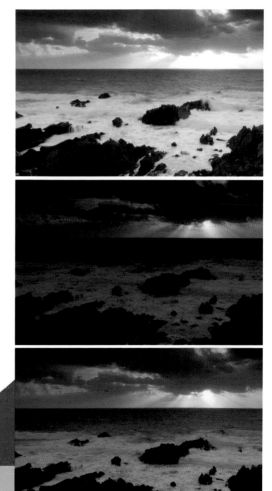

BRACKETING
The three images used to create the two-page spread that opened this chapter. The exposure was bracketed by ±1⅓ stops.

Canon EOS 7D with 17–40mm lens (at 27mm), three blended images at f/14, ISO 100

Saving your photos

Many digital SLR and SLR-style cameras can record either JPEG or RAW images, and both have certain advantages and disadvantages. However, to get the most out of HDR it is recommended that you shoot in RAW.

JPEG files

All digital cameras can record JPEG files, and some cameras, such as compact digital camera and cell phone cameras will only record images in this way. JPEG is so common because it is a standard both in digital photography and in other applications, such as illustrating web sites and text documents.

The immediate difference between a JPEG and a RAW file is how much less space a JPEG occupies on a camera's memory card or computer hard drive. This is because the information in a JPEG file is compressed to reduce the file size. This compression is achieved by reducing detail in an image: the greater the compression, the greater the loss of detail, and the more compression artifacts become visible.

This loss of detail can seriously reduce image quality when compression is set to maximum. It is also very important to realize that the process is irreversible, and once a JPEG has been saved there is no recovering lost detail.

JPEG images are always 8-bit files, which means there is less scope for manipulation in an image-editing program later. This has the consequence that you have to expose your images with more care than if you were shooting RAW.

> **Note**
>
> *There are recognized file formats designed for HDR images: Photomatix Pro supports Radiance and OpenEXR.*

ARTIFACTS
This photograph was saved as a JPEG at the lowest quality setting, so had maximum compression applied. This has resulted in a loss of fine detail.

RAW files

When your camera writes a JPEG file to the memory card, the contrast, color saturation, sharpness, white balance, and so on is all "fixed," based on how you've set the picture options on your camera. However, this is not the case with a RAW file, which is not processed by the camera. Instead, a RAW file is essentially the "raw" data captured by the camera's sensor.

Unlike a JPEG, a RAW file is not a standard file type. There are many different types of RAW file, each subtly different to the other, and this has several consequences. The first is that a RAW image is less immediately usable than a JPEG. You'd find it difficult to add a RAW image to a word processing document for example. The second consequence is that you need special software to process and convert your RAW images to a more usable file type. This all takes time and effort, so if you shoot RAW you must be prepared for potentially lengthy periods of post-production. Although saying that, as you're

reading a book about HDR imaging, you're probably prepared for that already!

RAW is ideally suited to HDR because the color data is saved as 12-bit (or increasingly commonly, 14-bit) information. This means that there is more scope for post-production work than there is with an 8-bit JPEG. In fact, there is so much image information that it's possible to create an HDR image from a single RAW file if care is taken when exposing it.

Why not try?

The DNG format. I convert my RAW files from the proprietary Canon RAW file format (CR2 files) to Adobe DNG. Adobe DNG is the closest there is to an industry standard for the RAW format. It is compatible with software such as Adobe Photoshop and Photomatix Pro.

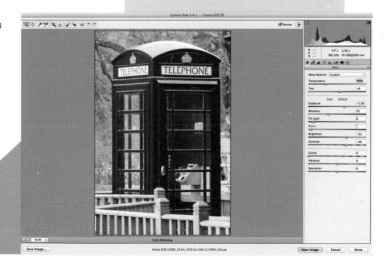

ADOBE CAMERA RAW
The dialog box shown when importing RAW files into Adobe Photoshop.

HDR options

Once you have shot your source images there are several techniques that you can use to create your HDR image. The following pages explain the available options.

Layer merging

Some scenes don't require anything other than a straight exposure, but when the contrast levels are high, there are those that will definitely benefit from the HDR approach. There are also scenes that fall somewhere in between these two, such as the image on the page opposite.

As a "straight" exposure it was difficult to achieve the look I was after: the blinding white-lit side of the windmill skewed the exposure so that other elements in the scene were underexposed. However, as I wanted to convey movement in the wind-blown leaves that I was using to frame the windmill, this made HDR a tricky proposition.

My solution was to shoot two exposures—one for the windmill and the other for the rest of the scene. Rather than creating an HDR image, I knew that I could use Photoshop to take the correctly exposed windmill from the first image, and using layers and layer masks, subtly add it to the second image. The key is to decide what is needed when you are on location and to then shoot accordingly, rather than trying to fix your images later without having the right resources.

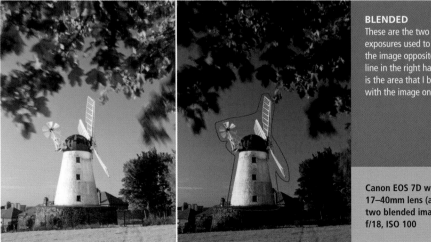

BLENDED
These are the two exposures used to create the image opposite. The red line in the right hand image is the area that I blended with the image on the left.

Canon EOS 7D with 17–40mm lens (at 30mm), two blended images at f/18, ISO 100

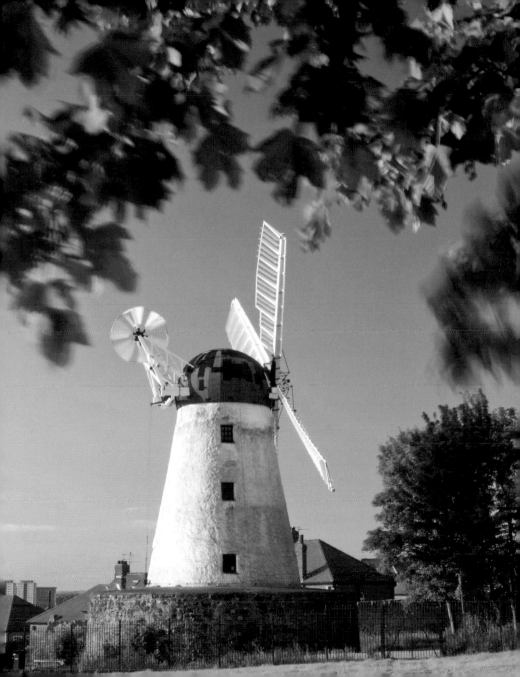

Exposure blending

This method is a recognized HDR technique that involves using a sequence of images shot at different exposure settings. The results are generally more naturalistic than images commonly associated with HDR, as software that uses this technique works by blending images on a pixel-by-pixel basis, choosing the "best" pixels from different regions of the image sequence to create the final blend. Software that can be used to create exposure-blended images includes Photomatix Pro (using the Exposure Fusion option) and the Enfuse plug-in for Adobe Lightroom.

Because several images are blended, there will still be problems with ghosting if there is movement between images, so the technique works best if a tripod is used when exposing the source images. The blended file is often a 16-bit file (as opposed to 32-bit), but this provides more than enough information for further editing.

The image on the opposite page was created by using the exposure blending technique. The lighting for the scene was natural, but high in contrast. Without additional lighting the difference between the highlights and the shadows was too great to be recorded by a single exposure. I therefore bracketed three images by ±2 stops. This was a wide enough range to extract detail from the shadows in the overexposed image, but retain highlight detail in the underexposed image.

SEQUENCE
Below is the bracketed sequence as it was shot, which included the "correct" exposure, an underexposed frame (at -2 stops), and an overexposed frame (at +2 stops).

Canon EOS 7D with 17–40mm lens (at 17mm), three blended images at f/4.5, ISO 200

Tone mapping

True HDR images are usually created from a series of bracketed exposures, but they need to be tone mapped before they can be saved as a standard image file. Tone mapping refers to the conversion of the image from high dynamic range to low dynamic range. This may not sound as though it is your intention, but it is essential if you want to view your photographs on a low dynamic range device such as a computer monitor, or on an even lower dynamic range medium such as a paper print. A good conversion should give you a sense of the high dynamic range within the limitations of the viewing medium.

Software such as Photomatix Pro allows you to adjust how your image is tone mapped and it is this process that can create the bewildering variety of HDR styles that are to be found in magazines, books, and on the Internet. Simple changes in detail contrast, saturation, and gamma can have a dramatic effect on the look of the final tone-mapped image.

Tone-mapping software broadly works in one of two ways: globally, and locally. Software that uses global operators adjusts every pixel in the image, based on its initial intensity: Photoshop's Brightness/Contrast tool is an example of this.

A local operator is subtler as it uses the location of individual pixels to determine their final intensity value. Pixels of a certain intensity will be altered differently if they are surrounded by darker pixels than when surrounded by lighter pixels. This technique helps to preserve detail in shadows and highlights, as well as maintaining local contrast, but it is very processor intensive. Both Adobe Photoshop and Photomatix Pro use the latter technique to create HDR imagery.

SEQUENCE
This is the bracketed sequence (below) as it was shot for the image on the page opposite, with the exposure set to ±2 stops. The sequence was then merged and tone mapped using Photomatix Pro.

Canon EOS 7D with 50mm lens, three blended images at f/2.0, ISO 100

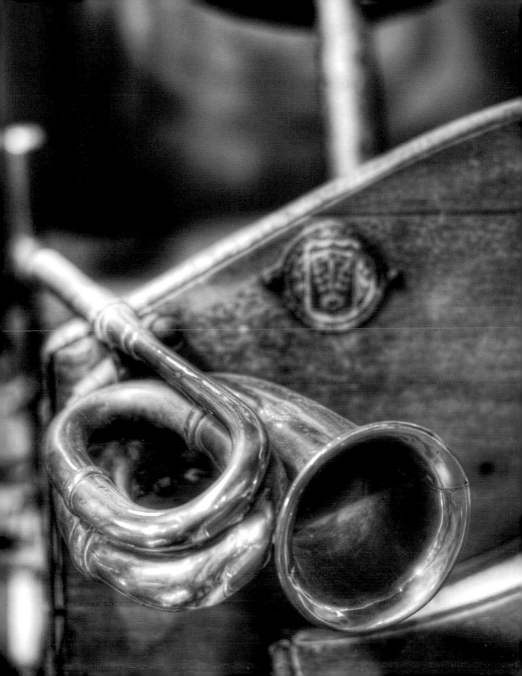

Any time, any place

As long as your camera allows you to adjust the exposure, you can shoot to create HDR images whenever the whim takes you. This image was created using the files from a compact digital camera. Passing through the station, the shape of the roof line intrigued me. Fortunately, I had the camera in my pocket to create the shot. I used a bench to support the camera during the bracketing process.

Camera: Canon Powershot G10
Lens: 6.1–30.5mm lens (at 8.9mm)
Exposure: Three blended images at f/4.5
ISO: 80

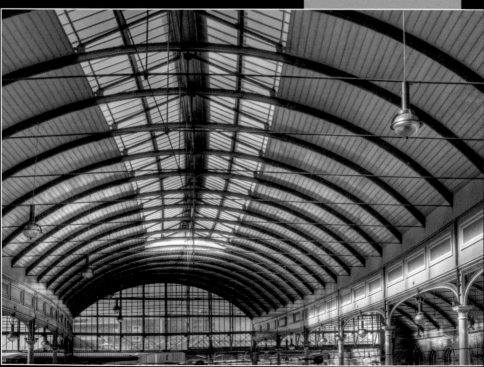

Other options

Once you've created your HDR image the work doesn't necessarily end there. This scene was blended from three different exposures, but after I had created my basic HDR image I imported it into Photoshop and added a light sepia tone, retaining some of the inherent blue/green of the statuette.

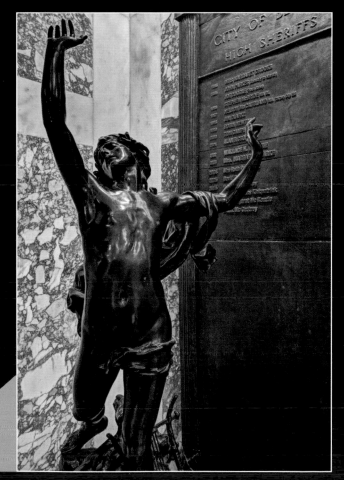

Camera: Canon
EOS 1Ds MkII
Lens: 50mm lens
Exposure: Three blended
images at f/11
ISO: 100

CHAPTER 2 EQUIPMENT

Equipment

There's no getting away from the fact that an interest in photography involves purchasing equipment, and there are a few basic items that will make your HDR photography more successful.

The first item on the list is, of course, a camera. All cameras are essentially designed to do the same job: they are boxes that control how much light reaches a light-sensitive surface so that an image can be formed. The image is made sharp by the use of a lens that focuses the light. Where digital cameras differ is in the range of options offered, how robustly they are made, and how large the sensor is (which ultimately affects the size of the camera and other factors such as depth of field).

NIKON D5100
Modern "entry-level" digital SLRs, such as the Nikon D5100, are extremely well specified given their (relatively) low purchase price.

When choosing a camera with the aim of shooting for HDR, there are a few useful options. The ability to bracket exposures automatically should be available, or at the very least the facility to apply exposure compensation. Next, a tripod socket for mounting your camera to a tripod will help make sure your images are aligned, and if your camera has a remote release socket then so much the better. However, a remote release is not essential, as most cameras have a self-timer facility that is equally effective at triggering the camera remotely and reducing the risk of camera shake. The ability to shoot RAW files is also useful, but only for ultimate image quality. With care, JPEGs can be used equally well.

Finally, the camera should feel "right" to you. Ergonomics are often overlooked when it comes to assessing the worth of a camera, but a camera that feels right in your hands is ultimately going to be more enjoyable to use. For this reason it's a good idea to actually try to use (or at least hold) your potential camera before you buy.

ANGEL *(Opposite)*
A good working knowledge of how your camera operates will allow you to plan and execute your HDR photography more rigorously.

Canon EOS 1Ds MkII with 50mm lens, 0.3 sec. at f/4, ISO 100

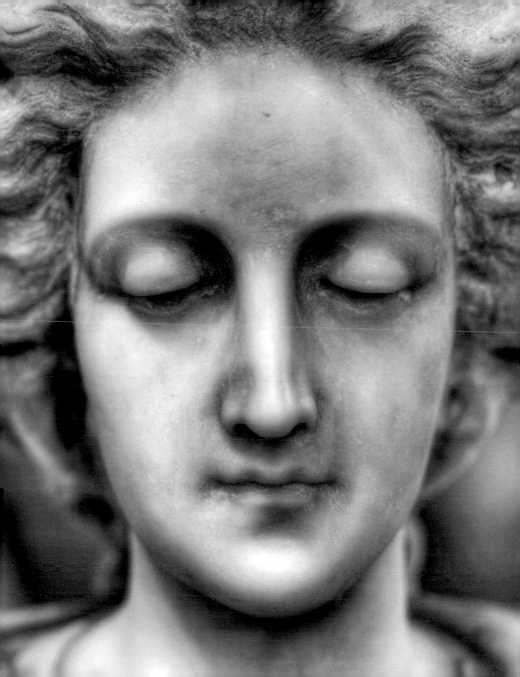

Photographic equipment

HDR photography can be created with very basic camera equipment, but it pays to choose your camera wisely. Ideally you should buy a camera that is simple enough to pick up and use straight from the box, but complex enough to allow you to grow as a photographer.

The digital SLR

The digital single lens reflex (or digital SLR) camera is one component of a modular system. Options available to the digital SLR user include interchangeable lenses and external flash units, as well as other accessories such as battery packs, grips, and remote releases. The most successful digital SLRs in terms of sales are those produced by Canon and Nikon, and it's fair to say that these systems are most heavily supported by third-party manufacturers, too. However, that's not to dismiss cameras produced by the likes of Sony, Pentax, and Olympus—all have their following.

The one big drawback with the digital SLR is that once you've "bought in" to a system, it's expensive to swap over to another. Accessories such as lenses are generally not compatible between different camera systems, and the more you've invested, the more you will potentially lose by trading in.

In addition to digital SLR cameras are modular cameras that no longer use a reflex mirror and rely instead on "Live View" using either the LCD on the back of the camera or an Electronic Viewfinder (EVF). These are not "true" digital SLRs, but they offer a comparable range of features, and have a similar level of support. The Micro Four Thirds cameras from Panasonic and Olympus are good examples of this type, as is Sony's NEX range.

For the HDR shooter either a digital SLR or a non-reflex interchangeable-

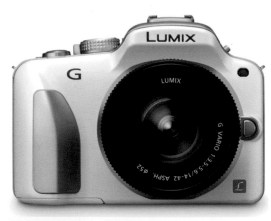

MICRO FOUR THIRDS
The Panasonic Lumix G3: a non-reflex interchangeable-lens camera.

lens camera is a good choice. Even the most basic of these will have options that allow you to adjust the exposure and bracket your shots, all at a respectable frame rate. The majority will also allow you to record RAW files, which gives you the best chance of maintaining image quality all the way through the HDR conversion process.

Compact digital cameras

Modern compact digital cameras are capable of producing outstanding image quality, but they do have a few drawbacks when it comes to HDR shooting. It's a rare compact digital camera that allows you to bracket your exposures automatically, for instance, and very few will allow you to shoot RAW. However, find a compact digital camera that is able to do both of those and HDR becomes a more viable proposition. Models that currently fit this criteria are the Canon Powershot G12, Nikon Coolpix 7000, and Panasonic Lumix DMC-LX5. In fact, the Powershot G12 actually goes a step further and includes an in-camera HDR option, although the results are saved as JPEG files rather than more versatile RAW images.

A number of compact digital cameras (and an increasing number of digital SLRs) also offer a pseudo-HDR option when shooting JPEG. This is offered under a variety of names, such as DR Correction or D-Range Optimizer, but what they have in common is that they adjust the tone curve during in-camera processing to extract detail from the shadow areas of an image and to reduce the risk of highlights blowing out. However, this is not true HDR, and with this option switched on there is greater chance of noise appearing in the shadow areas of images.

Compact digital cameras are most useful to the HDR shooter as "walk-around" cameras suitable for a more spontaneous approach. Several of the images in this book were created from bracketed images taken using a compact digital camera on days when I didn't want to carry around much equipment.

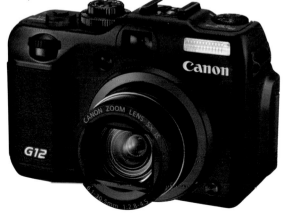

CANON POWERSHOT G12
Capable of shooting RAW and bracketing images automatically.

Lenses

All lenses have a specific focal length (or in the case of a zoom lens a variable focal length between two specific values). Focal length is a measurement of the distance from the optical center of the lens to the focal plane when a subject at infinity is in focus (the focal plane being the point where the sensor is located).

ANGLE OF VIEW
This image was shot using a full-frame camera and a 24mm lens. If I had used the same lens on an APS-C sized sensor the angle of view would have been reduced to the area indicated by the red box. On a compact digital camera the angle of view would be smaller still, as shown by the green box.

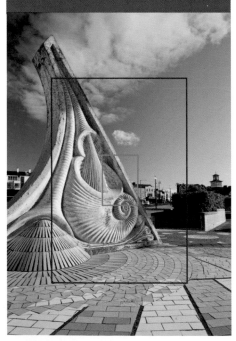

The focal length of a lens also affects its angle of view, which is the angular extent of an image projected by the lens onto the sensor. A short focal length lens has a wide angle of view and so is known as a wide-angle lens, while a long focal length lens has a narrow angle of view and is known as a telephoto lens.

However, the size of the sensor also affects the angle of view of the image recorded by the camera. On a full-frame camera a 50mm lens has an angle of view of 47°, for example, whereas on an APS-C (cropped-frame) camera, the angle of view will only be 32°. This is due to the smaller sensor size "seeing" a smaller area of the image circle that is formed by the lens. Therefore, to achieve roughly the same angle of view on an APS-C camera, a wider angle focal length must be used—a focal length of 35mm in this example.

The sensors in compact digital cameras are smaller still, so even wider focal lengths must be used to achieve an angle of view of 47°. This is why the focal length given on a compact digital camera's specifications is often noted as a "35mm equivalent," as well as the true focal length of the lens. The 35mm equivalent simply makes it easier to compare the effective focal length of different camera formats.

Note

The focal length of a lens also affects the depth of field achievable at a given aperture: longer focal lengths produce less depth of field.

Extreme wide-angle lenses

Full-frame sensor range: 14–20mm
Cropped sensor range: 8–15mm

These lenses have an enormous angle of coverage, but this results in severe levels of distortion within the image. Straight lines are rendered as curves and the spatial relationships between elements of the scene are highly exaggerated. These lenses are often used for effect to create an extreme sense of space. Compositionally they can be difficult to use, as a scene can look very empty unless care is taken to get very close to your subject. These lenses are rarely used as portrait lenses, because the spatial distortion is very unflattering.

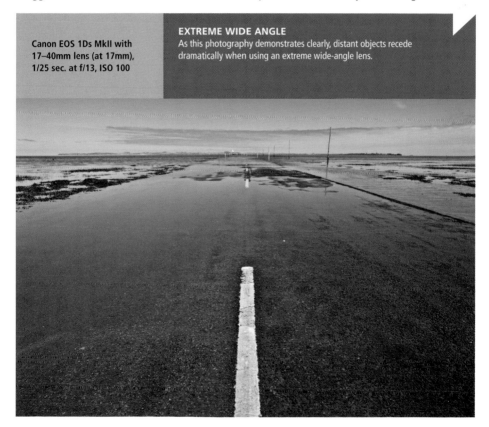

Canon EOS 1Ds MkII with 17–40mm lens (at 17mm), 1/25 sec. at f/13, ISO 100

EXTREME WIDE ANGLE
As this photography demonstrates clearly, distant objects recede dramatically when using an extreme wide-angle lens.

Wide-angle lenses
Full-frame sensor range: 22–35mm
Cropped sensor range: 17–24mm

These lenses are most closely associated with landscape photographers because they help to convey a sense of space. Spatial relationships within a scene are less exaggerated than they are with an extreme wide-angle lens, but the perspective is unnatural in comparison to how we perceive the world through our eyes.

Getting the exposure right with wide-angle lenses can be tricky, as the intensity of light across the scene can vary considerably, especially when photographing landscapes. This will be reflected by uneven exposure in your image. For this reason, HDR imaging is often the ideal partner to a wide-angle lens.

Standard lenses
Full-frame sensor range: 35–50mm
Cropped sensor range: 25–35mm

The perspective of a standard lens is roughly similar to how we view the world, so spatial relationships within an image appear natural. The full-frame standard lens is generally recognized as a 50mm prime (fixed focal length) lens. Prime lenses tend to have wide maximum apertures, and so documentary photographers wanting to shoot street scenes often use a 50mm lens. Its capabilities in low light and its pleasing natural perspective makes for an unbeatable combination in this role.

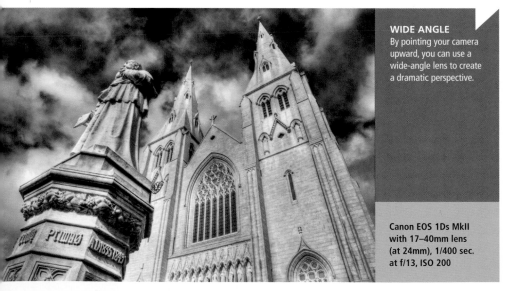

WIDE ANGLE
By pointing your camera upward, you can use a wide-angle lens to create a dramatic perspective.

Canon EOS 1Ds MkII
with 17–40mm lens
(at 24mm), 1/400 sec.
at f/13, ISO 200

Short telephoto

Full-frame sensor range: 60–200mm
Cropped sensor range: 50–150mm

The perspective of the short telephoto is noticeably more compressed than it is with a standard lens, so objects in a scene appear spatially closer together and therefore more "intimate." Portrait photographers often use short telephoto lenses because it allows them to be slightly further back from their subject, which is far less intimidating and stressful for the person being photographed.

Extreme telephoto

Full-frame sensor range: 300mm+
Cropped sensor range: 200mm+

The perspective of an extreme telephoto is very compressed and objects that aren't necessarily close spatially can look "stacked" together. Nature photographers and photojournalists most often use extreme telephotos as they allow them to fill the frame with the subject, without needing to get physically close to them. Extreme telephotos have a very narrow angle of view, which means that objects are often isolated from their background and thus become the dominant element in the image. The narrow depth of field of an extreme telephoto enhances this sense of isolation.

> ### Note
> *Although perspective appears to change with focal length, this is not the case. If you cropped an image taken using a wide-angle focal length so that it matched an image taken from the same position with a much longer focal length, you would discover that the two are, in fact, identical.*

KEEPING YOUR DISTANCE
Short telephoto lenses are ideal when you don't want to get too close to your subject.

Canon EOS 5D with 100mm lens, 1/200 sec. at f/7.1, ISO 200

Flash

Generally, if a camera doesn't have a built-in flash it will have an accessory hotshoe that you can attach one to. Flash has been used for decades as a way of adding more light to a scene, either to illuminate it entirely, or as a way of adding fill-in light to even out the exposure. The latter is particularly useful when a subject is backlit and the contrast is high. At this point you'd be forgiven for thinking that flash is not necessary when shooting HDR, but as you will see in the following chapter, flash does have its uses and when used correctly, can improve the look of certain HDR shots.

Built-in flashes tend not to be very powerful and are only really suitable as fill-in lights. External flash units are usually far more powerful, but the problem that both types often have is that they provide very direct, frontal lighting, which is not particularly flattering.

This is where an external flash can be advantageous. If you can angle the head of the flash, it is possible to use a technique called "bounce flash," which is when the flash is pointed upward at the ceiling or across to a wall to "bounce" the light onto the subject. Bounced light is far softer than direct flash, although the flash does need to be relatively powerful, as some of the light will be absorbed by the surface it is bounced from, and the light also has to travel a greater distance.

Another way to soften the light from a flash is to use an accessory diffuser that fits over the flash head. Again, a certain amount of light will be lost, but using a diffuser means that you don't need to rely on a (white) wall or ceiling to soften the light.

LUMIQUEST
A Lumiquest flash diffuser.

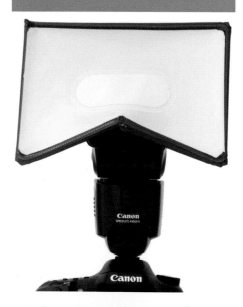

EGYPT *(Opposite)*
When processing your HDR images, don't over lighten the shadows: if there was contrast in the scene, try to convey this so that your image doesn't appear flat.

Canon EOS 5D with 50mm lens, 1/250 sec. at f/13, ISO 400

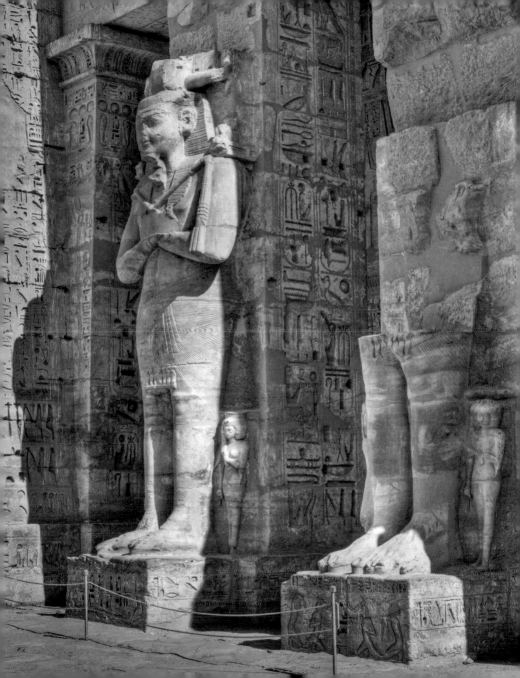

Tripod

One of the key requirements when shooting multiple images for HDR conversion is keeping your camera steady between shots.

Choosing a tripod

Using a tripod is the most obvious method of supporting your camera, and it's something that has been used since the dawn of photography. Originally they were essential, as early photographic emulsions were very insensitive to light and exposures of minutes or hours were

STABLE PLATFORM
A tripod is a necessity when shooting long exposures. It would be impossible to handhold a camera for the 1/2 sec. it took to create this shot.

Canon EOS 7D with 17–40mm lens (at 18mm), 1/2 sec. at f/14, ISO 100

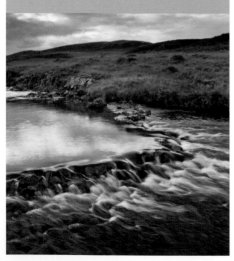

often required. Now we have digital cameras that have such high ISO settings that they enable images to be successfully captured handheld, even when the light levels are extremely low. As a result, modern cameras—especially when coupled with a stabilized lens—can reduce the risk of camera shake to almost zero.

The biggest problem with a tripod is that it can restrict spontaneity—setting up is invariably time consuming. But this is also a strength. By forcing you to slow down, a tripod will make you consider your photography more carefully. It will also open up new creative avenues by allowing you to deliberately shoot at longer shutter speeds for effect. More importantly in the context of this book, it will allow you to shoot exposure sequences for HDR images, without your camera moving between frames.

If you decide to invest in a tripod, there are certain factors you need to consider carefully when making your choice. Tripods vary in size and weight, and although a small, light tripod will be easier to carry, it may not offer the stability of a larger model—particularly if your camera (and lens) is heavy. However, the flip side to this is you may be less inclined to regularly carry and use a heavier tripod, so you need to find a compromise that you are happy with. If possible, try out potential tripods in a camera store to see which feel right to you.

Tripod heads

Tripods either have a built-in head—typically this will be a three-way type—or they will require you to buy and fit a separate head. A tripod that requires a separate head is the more flexible (and more expensive) option, but you don't need to use a combination made by the same manufacturer. As long as the thread on the screw that joins the head to the tripod legs is compatible, you can mix and match as required. As with tripods it pays to try out a head before purchase to see if it suits your style of working.

There are a number of different types of tripod head. As already mentioned, the most common is the three-way head. As the name suggests, this type of head allows you to move your camera in one or all of three directions (horizontal, vertical, and tilt sideways). When the camera is in position, the head is locked to prevent further movement.

Ball-heads allow you to move the camera in any direction, thanks to the ball joint that gives them their name. They have a good weight-to-strength ratio, and even small ball-heads can generally hold a relatively heavy camera steady. The one drawback with ball-heads is that they can be tricky to use, and making fine adjustments is sometimes difficult as the head is free to move in any direction when it isn't locked down.

Finally, there are geared heads, which are by far the most precise and easily adjustable tripod head you can buy. However, this ease of use comes at a cost: most gear heads are far heavier than three-way or ball-heads, which tends to limit them to studio use, rather than outdoor photography. Regardless of the type of tripod head you prefer, a useful feature to look out for is a quick-release mechanism. This allows a plate to be screwed into the tripod socket on the base of your camera, which can be clipped quickly onto the tripod head. This makes using a tripod a less frustrating and time-consuming business.

Tip
Rather counterintuitively, using a tripod in conjunction with image stabilization can result in unsharp images, so it is advisable to turn stabilization off whenever your camera is tripod-mounted.

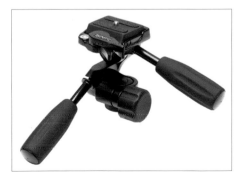

THREE-WAY HEAD
The Benro HD1 (right) is a traditionally styled three-way tripod head.

Good tripod technique

Many tripods have a center-column that can be raised or lowered as required. In theory, center-columns are a good idea, as they enable the camera to be positioned at a greater height without having to make the tripod legs physically longer (saving on both weight and bulk). However, using a center-column raises the center of gravity of the tripod, making the set-up more prone to instability and increasing the risk of unsharp images. Therefore, it is best to try and keep your use of the center-column to a minimum, and certainly don't use it fully extended if it's windy.

It's a good idea to use a remote release (either infrared or a cable) to fire the shutter when the camera is on a tripod. The idea is that the camera is not touched when the shutter is fired remotely, which reduces the chance of it being knocked accidentally. Another benefit of using a remote release is that it allows you to look at the scene around you when you fire the shutter. This makes it easier to anticipate when the shutter should be fired, particularly if the scene is changing outside the area of your framed composition.

Ironically, one of the potential causes of unsharp images when using a digital SLR is the camera itself. When the shutter-release button is pressed—assuming the camera is not in Live View mode—the reflex mirror is swung upward, out of the way of the shutter. This motion—known as "mirror slap"—causes a slight vibration that can result in noticeable camera shake. To counter this, activate your camera's mirror-lock and also use the self-timer to trigger the shutter. With these two options set, the mirror will move upward when the timer starts, and any vibration this causes will have dissipated by the time the shutter is fired.

SOFT
This (handheld) image has been marred by noticeable camera shake.

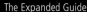

Camera: Canon EOS 7D
Lens: 17–40mm lens (at 40mm)
Exposure: 1 sec. at f/14
ISO: 100

TIDAL
If you're keen to experiment with long shutter speeds,
a tripod is a must. This image was created in Photomatix
Pro from a single RAW exposure.

Filters

You'd be forgiven for thinking that you don't need to use filters when you're shooting for HDR, but they still have their uses. More importantly, the effects of some photographic filters cannot be replicated easily in post-processing.

Filter types

A filter is a piece of glass, gelatin, or optical resin that alters the light that passes through it in a measurable way. There are two main ways to fit a filter to the lens on your camera. The first is to screw the filter directly to the filter thread on the lens, the other is to slot the filter into a holder that is then fixed to the lens.

Some filters are highly recommended if you want to improve your photography, while others are less indispensable. However, just because a particular filter isn't strictly necessary, does not mean that it's not fun to use and there may be one that fits your particular photographic style.

EFFECTS FILTERS
Effects filters, such as soft focus used here, can now be replicated in post-processing. However, they are fun to use and the results can be seen instantly at the time of shooting.

Star filters are a good example: these filters were in vogue during the 1980s, but now their use is less common.

You will be able to find most filters available as both the screw-in and slot-in types, and screw-in filters are typically cheaper than the equivalent slot-in type. However, if you have lenses with different filter thread sizes you will need to buy screw-in filters for each of them. Alternatively, you could buy a screw-in filter that will fit your lens with the biggest filter thread and then purchase step-up rings to fit it to your other lenses.

A filter holder is an initially more expensive option, as you have to buy the holder before you start your filter collection, but once you have the holder you only need to buy different sized adapter rings to use it (and all your filters) on different lenses. There is a variety of filter holder manufacturers such as Cokin, Hi-Tech, and Lee, but the disadvantage of filter holder systems is that once you've bought a system you may be locked into buying that manufacturer's filters, limiting your filter choice.

UV and skylight filters

Atmospheric haze will visibly reduce the sharpness of distant objects in your images. Both UV (ultraviolet) and skylight filters will help to reduce the effects of haze, as well as correcting for the over-blueness caused by ultraviolet light.

Generally, exposure is not affected by the use of these filters, but a skylight filter is slightly pink and will affect the color balance of your images (although this may be neutralized if you have the white-balance set to Auto). Many photographers leave UV or skylight filters permanently attached to their lenses to protect the front element of the lens from damage, and there are now clear "protective" filters available for this very purpose.

LEE FILTER HOLDER
A slot-in filter holder with a polarizing filter fitted.

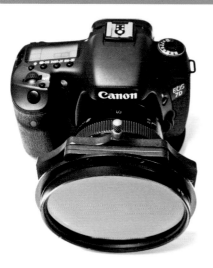

Note
Some filters, such as neutral density graduated filters, are only really useful when used with a filter holder.

Polarizing filters

When light rays strike a non-metallic surface they bounce off and are scattered in all directions. Technically, the light has become polarized and this has the effect of decreasing the color saturation of the surface. In the case of glass and water, this will also reduce the apparent transparency.

A polarizing filter cuts out all polarized light perpendicular to the axis of the filter, restoring color saturation and the transparency of glass and water. Polarizing filters work best when they are at approximately 35° to a non-metallic surface, and not at all when they are at 90°. The strength of the polarizer effect is varied by turning it around the lens axis. This is achieved either by rotating a front element on the filter or by rotating it within a filter holder.

A common use for a polarizing filter is to deepen the blue of the sky. Again, this works best at a specific angle, in this instance when the filter is used at 90° to the sun. The effect is visibly reduced when the polarizer is used at a greater or lesser angle. It is worth noting that the polarizing effect can be problematic when using ultra-wide angle lenses: as more sky is included, it's often possible to see an unnatural deep blue band running across the sky.

Notes

The effect of a polarizing filter cannot be reproduced in post-production.

Polarizing filters have no effect on the light reflected from a metallic surface.

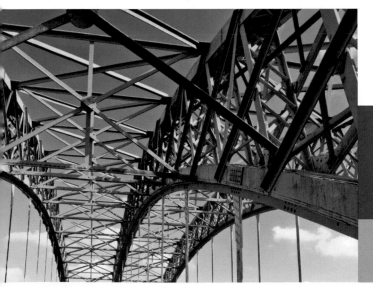

POLARIZED
This image was shot with a polarizing filter fitted to a wide-angle lens. I managed to hide the effect of "banding" by hiding the transition behind the structure of the bridge.

Canon EOS 7D with 17–40mm lens (at 17mm), 1/6 sec. at f/13, ISO 100

Neutral density filters

There may be times when the intensity of the light you are working in stops you from using a particular shutter speed and aperture combination. Digital cameras often have ISO 100 as a base ISO, and some use 200. This can be restrictive if you want to use a long shutter speed without setting a very small aperture.

Neutral density (ND) filters are essentially "sunglasses" for cameras, in that they reduce the amount of light entering the lens. Neutral density filters are neutral in color (hence the name) and are available in different strengths. A 1-stop ND filter has the same effect on the shutter speed and aperture combination as if you changed from ISO 100 to ISO 50, a 2-stop filter is equivalent to changing from ISO 100 to ISO 25, and so on.

ND FILTER
A 3-stop ND filter was needed to achieve the five-second shutter speed I wanted for this shot.

Canon EOS 7D with 17–40mm lens (at 20mm), 5 sec. at f/13, ISO 100

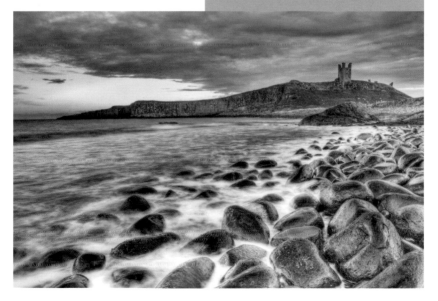

ND graduated filters

The ND graduated filter ("ND grad") is related to the neutral density filter, with the main difference being that an ND grad has a transparent bottom half and a filtered top half. The main users of ND graduates are landscape photographers, who often use them to balance the exposure of a bright sky with a darker landscape. As with plain ND filters, ND graduated filters come in a variety of strengths, as well as different types: soft, hard, or very hard. This refers to how abrupt the transition from the transparent to filtered area is.

One of the big problems with ND graduates is that the exposure of everything covered by the filtered area is affected, so unless your horizon is perfectly straight this can mean elements of your landscape above the horizon will be unnaturally darkened. Using a soft ND graduate can minimize this, but because the transition is less well defined it can often be difficult to place a soft graduate filter precisely where it is needed. Personally, I use hard ND graduate filters because they are easier to position, but use HDR or software-blending techniques when this approach is problematic.

While it is possible to buy ND graduates as screw-in filters, they work best when used with a filter holder, which allows them to be moved up and down (or rotated) so that they can be positioned precisely where needed.

OVER-COMPENSATED
The key to using ND graduated filters is to use the right strength for the scene you are photographing. In this image I used a 3-stop ND graduate, but a 2-stop filter would have been a better choice. As a result, the bottom half is now unnaturally light compared to the sky.

Canon EOS 7D with 10–22mm lens (at 10mm), 1/50 sec. at f/10, ISO 100

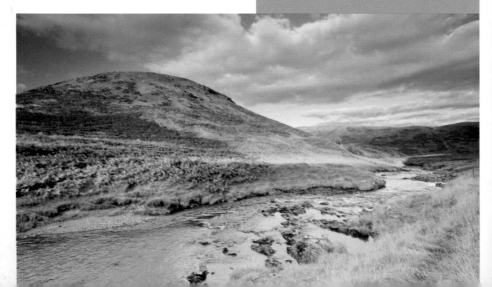

Camera: Canon EOS 7D
Lens: 17–40mm lens (at 20mm)
Exposure: 1/250 sec. at f/10
ISO: 100

Shooting toward the sun means coping with extreme levels of contrast. As this image was shot handheld I decided to use a 3-stop ND graduated filter to deal with the contrast, rather than relying on an HDR merge in post-production.

Computer equipment

Some cameras have the built-in ability to create HDR files, but it's far more likely that you will be creating your HDR images on a computer of some description.

Choosing a computer

Personal computers can take one of three forms: a desktop tower with separate monitor, an all-in-one unit, or a laptop. Typically, desktops have the best cost-to-performance ratio, although there is the added expense of the monitor to be considered. Laptops are ideal if you intend to travel frequently and need your computer to go with you, but the smaller screen size can make image editing more difficult.

DUAL-CORE
Modern desktop PCs, such as this Dell Inspiron 560, now usually come with multi-core processors. (Image courtesy of Dell Inc.)

Performance

There are three potential performance bottlenecks that will slow down your attempts to create HDR images, and waiting for your computer to catch up can be a frustrating experience. It is therefore worth considering a gentle upgrade to a few key components if this is the case.

The first is really only a consideration if you are buying a computer, and that is the CPU (Central Processing Unit) or, simply, "the processor." The greater the resolution of your camera (and the more source images you use to create an HDR merge), the more data your computer will have to work through. The slower the processor in the computer, then the slower that data is processed. Most current PCs now come with multi-core processors, which means a number of separate processors are built into one component. The two most common types, Dual-core and Quad-core, have two and four processors respectively.

Multi-core processors run in parallel, dividing computing tasks between the different processors to maximize performance. Theoretically, the greater the number of cores, the greater the efficiency, and therefore the faster your software will

run. If your software is designed for multi-core processors—as Adobe Photoshop CS5 is—then it will run far more efficiently than if used on a single-core system.

The second element of a computer that affects performance is the memory or RAM (Random Access Memory), which is where the computer stores information temporarily. If an application, such as Photoshop, does not have enough physical memory to run, then it will start to use the hard drive as "virtual memory" instead. As a hard drive is a mechanical device, it takes time to read and write data, causing delays to the completion of tasks.

Increasing the memory in a PC is often a simple way to improve performance, but how much memory you can install will depend on the computer and the operating system. If you have an up-to-date PC running the latest 64-bit operating system (currently Windows 7 or Apple OS 10.7) then you may

well find that adding more RAM becomes a necessity rather than a luxury.

The final component that can affect the performance of your PC is the hard drive. A near-full hard drive will cause lots of problems, both in terms of running out of storage and of hampering the efficiency of the operating system. Shooting for HDR images means making many more exposures than you would for "normal" photography, so it's very easy to fill a hard drive relatively rapidly. If your budget will allow, aim to buy the largest hard drive you can for your computer, and consider investing in external hard drives as well.

SOFTWARE
Well-written software, such as Adobe Photoshop, should allow you to choose how your computer's available memory is used and which hard drive should be used as virtual memory if required. In Photoshop, this is referred to as the Scratch Disk.

Preferences

General	Performance						
Interface							
File Handling	┌ Memory Usage ───────────		┌ History & Cache ───	OK			
Performance	Available RAM: 3072 MB		History States: 20 ▸	Cancel			
Cursors	Ideal Range: 1689–2211 MB			Prev			
Transparency & Gamut	Let Photoshop Use: 2150 MB (70%)		Cache Levels: 6 ▸	Next			
Units & Rulers	[-] [+]						
Guides, Grid & Slices							
Plug-Ins	┌ Scratch Disks ────────────────────		┌ GPU Settings ───				
Type		Active?	Drive	Free Space	Information	Detected Video Card:	
	1	✓	Macintosh HD	605.41GB		ATI Technologies Inc.	
						ATI Radeon HD 6770M OpenGL Engine	
					▲ ▼		
	┌ Description ────────────────────						

Monitors

The LCD screen is now the only choice when buying a new monitor, and they have a number of advantages over their CRT predecessors: LCD screens consume far less power, have more consistent color, and take up far less space on a desk. However, they do have one drawback that you should be aware of when editing images.

Not all LCD screens are equally well made, and cheaper screens often have a relatively small viewing angle. If you are sitting at the optimum angle, the screen will look evenly lit, but if you move away from this position—

even slightly—the screen will darken and the colors will shift. This quirk means that it's almost impossible to see anything on the screen when you are looking at it obliquely, so if you are considering buying a new monitor you should look for one with a viewing angle of at least 160°.

Calibration

For accurate color you should also calibrate your monitor, which can be done by running display calibration software. Display Calibration Assistant is built into the operating system on Apple Mac computers, while Windows users have QuickGamma. However, software calibrators aren't really that effective, as they are based on you determining what looks best on screen. A better option is to use a hardware calibrator instead, which measures on-screen color with far greater precision for consistent, accurate color through the image-editing process. Such profiling devices are now relatively inexpensive.

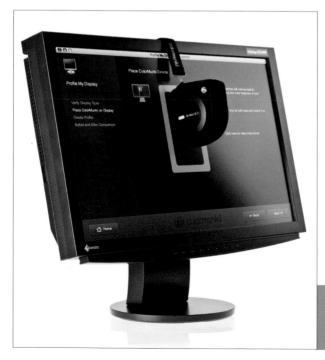

**COLORMUNKI
MONITOR CALIBRATOR**
(Image © X-Rite, Inc.)

Scanners

The most common way to create an HDR image is to blend exposures taken with a digital camera. However, if you have a sequence of bracketed images shot using a film camera, there is no reason you couldn't scan and use those too.

The most familiar type of scanner is the flatbed scanner. For scanning film, the most useful are those that have a built-in light hood, but you should also pay close attention to the scanner's resolution. Cheaper flatbed scanners often have quite a low resolution, which is fine if you're scanning large film formats, but is less than ideal when scanning 35mm film. It is possible to buy dedicated film scanners, but these are relatively rare now. However, a film scanner will give you better results than a flatbed scanner with smaller film formats.

Whatever hardware you use, you will get the best results by scanning in 16-bit mode (often referred to as 48-bit in scanning software). Set the scan exposure to manual and make sure that the exposure you set encompasses the full range of tones in the image. Some scanning software will initially use an automatic exposure that loses some of the tonal range of the image unless you intervene.

If you are thinking about buying a scanner, there are a few points to consider if it is to be useful for HDR work. As mentioned, one of the most important is the resolution. The quoted figure to look out for is the optical resolution, which is most often given in dots per inch (or dpi). Some scanners boast an impressively high resolution that is achieved through software interpolation. Not only is this something you can achieve yourself using any decent image-editing program, but it is also inferior to optical resolution. For scanning film, an optical resolution of 1200 dpi or higher is the minimum you should consider.

CANOSCAN 9000F
Canon's top-of-the-range flatbed scanner, which is capable of scanning both slide and negative film.

The second point to consider is the DMax of the scanner. The DMax is a measure of the tonal range the scanner can resolve—or more succinctly, its dynamic range. The greater the DMax of a scanner, the more detail it will be able to extract from the shadows of a slide or the highlights of a negative. To scan slides or negatives a scanner should have a DMax value of at least 3.4.

When scanning film for HDR purposes, there are two main problems you will encounter. The first is dust. Film attracts dust and it's difficult to keep it clean. Before you scan, make sure you blow off as much dust as you can, and then be prepared to clone out any that remains using your image-editing software. Some slide scanners have automatic dust removal systems such as ICE, although the additional processing increases scan times.

The second problem will be aligning your images. It is virtually impossible to scan a sequence of images from film and have them all align perfectly. Fortunately, software such as Photomatix and later versions of Photoshop will automatically align a sequence of images, and this will alleviate this problem.

DIRECT SCANNING
With a flatbed scanner you can scan flat objects to create HDR images. I scanned this leaf using three different exposures and then combined them in Photomatix.

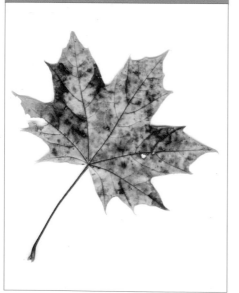

EVENING *(Opposite)*
Toward the ends of the day the light is "warmer" and there is more chance of interesting side-lighting across the landscape.

Canon EOS 1Ds MkII with 17–40mm lens (at 26mm), 1/2 sec. at f/18, ISO 100

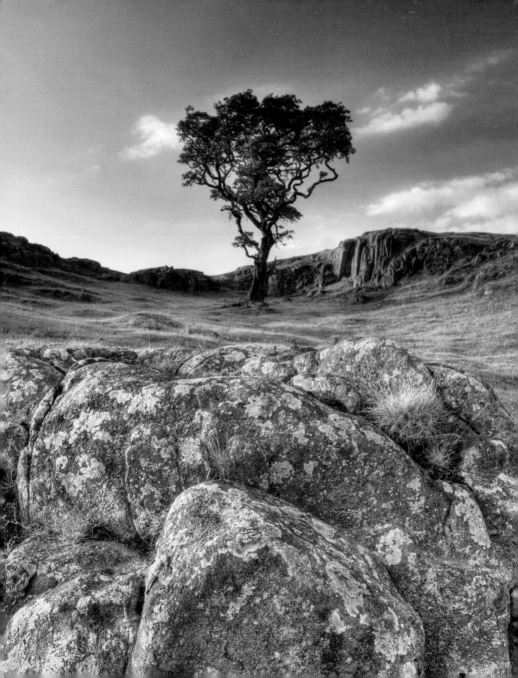

Software

The HDR software you choose to use will determine the look of your images. However, HDR images often benefit from polishing after they've been processed, so you also need to consider a "standard" image-editing program as well.

Adobe Photoshop

Adobe Photoshop is now inextricably linked with digital photography. However, as it is aimed at a multitude of different users, not just photographers, there are areas of the program that it's possible never to encounter because they simply aren't relevant. With version CS2, it became possible to convert a sequence of images into a 32-bit HDR using Photoshop and with each new version of the program the range of tools that can be used to edit a 32-bit HDR image has increased, and the HDR merge itself has become more sophisticated. This aspect of Photoshop is covered in more detail later on.

Adobe Lightroom

Adobe Lightroom uses the same core technology as Photoshop, but is aimed purely at photographers. Lightroom differs from Photoshop in that it is both a photo editor and a workflow tool. The basic Lightroom program does not currently support HDR merging in the way that Photoshop does, but there are third-party plug-ins available that provide HDR capability. Photomatix Pro is available as a Lightroom plug-in, for example, as are exposure blending plug-ins such as Enfuse by the Photographer's Toolbox.

MERGE TO HDR
Adobe Photoshop's HDR capabilities have become more refined in recent versions of the program.

Lightroom and Enfuse

Enfuse is compatible with both Mac and PC versions of Lightroom, and is described as "donationware"—a donation to Photographer's Toolbox is required to unlock certain features. However, Enfuse isn't a "true" HDR application in that it only generates 16-bit exposure-blended images, rather than 32-bit floating-point files.

Blending images is very straightforward and is controlled by a simple dialog box with four different tabs. Enfuse will attempt to align your images if they aren't perfectly aligned (useful for those occasions when you've shot your image sequence handheld), and you can adjust how the images are blended, although the default set-up works on most occasions. When you begin the blending process you can choose to output the final image in either JPEG or TIFF format, with TIFF being the recommended option as it is a 16-bit file that is more suited to further adjustment if required. There is also the choice of importing the resulting image back into your Lightroom database for further editing.

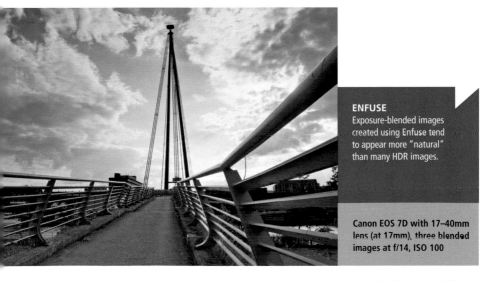

ENFUSE
Exposure-blended images created using Enfuse tend to appear more "natural" than many HDR images.

Canon EOS 7D with 17–40mm lens (at 17mm), three blended images at f/14, ISO 100

Adobe Photoshop Elements

Adobe Photoshop, as befits its complexity, is an expensive proposition if it's just to be used occasionally. Fortunately, Adobe produces a consumer version of the package called Elements, which is far more affordable. Since version 8 (at the time of writing the current version is 10), Elements has had the capability to merge a series of exposed images to create an HDR-effect final image. The range of controls in Elements is far less extensive than those found in the full version of Photoshop, but it's an interesting and simple way to "dip in" to the world of HDR. Elements is available for both Windows and Mac.

Photomatix

HDRSoft's Photomatix is a highly regarded HDR image creator that is available in several forms. It can be used as a plug-in for Adobe Photoshop, Adobe Lightroom, and Apple Aperture, or as one of two standalone programs—Photomatix Pro and Photomatix Essentials. Photomatix Pro is the more expensive, but more comprehensive, version of the program, while Photomatix Essentials is a cut-down version with fewer features and a lower retail price. Both versions are available for Windows and Mac.

ADOBE PHOTOSHOP ELEMENTS
Recent versions of Elements include Photomerge Exposure, for creating HDR-effect images.

Free software

You don't necessarily have to spend vast sums of money on commercially-developed HDR software—there is a number of freeware and donationware alternatives available:

Picturenaut

Picturenaut features tools such as automatic image alignment, color balancing, noise reduction, and exposure correction, and tone maps images using one of four methods: Adaptive Logarithmic, Photoreceptor Physiology, Bilateral, and Exposure. Picturenaut also supports the use of plug-ins, so can be expanded readily. It is currently only available for Windows.

FDRTools

Supports the use of JPEG, TIFF, PNG, BMP, Radiance RGBE, and OpenEXR files, and also has a built-in RAW converter (plus DCRAW) so RAW files can be easily used. When images are imported they can be auto-aligned if there has been camera movement between exposures and there are two tone mapping options: Simplex and Receptor. FDRTools is available for both Windows and Mac.

FDRTOOLS
FDRTools' Advanced control panels provide you with plenty of options for controlling the look of your HDR image.

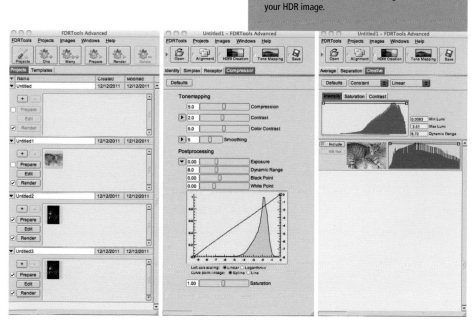

Wide-angle lenses

If you really want to emphasize lines in a landscape, shooting low down with a wide-angle lens is one of the most dramatic ways to achieve this. Getting down low will also help you fill the foreground.

Camera: Canon EOS 1Ds MkII
Lens: 17–40mm lens (at 17mm)
Exposure: Three blended images at f/14
ISO: 100

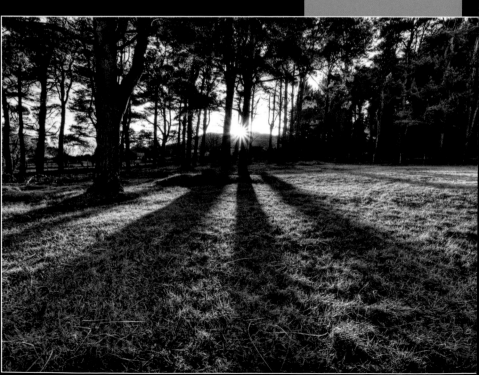

Prime lenses

My 50mm prime lens is one of my favorite lenses. Not only is the perspective relatively natural, but it has a large maximum aperture. This means I can easily create a very shallow depth of field to concentrate attention on the important areas of a scene.

Camera: Canon EOS 5D
Lens: 50mm lens
Exposure: Three blended images at f/2.8
ISO: 100

CHAPTER 3 EXPOSURE

Introduction

HDR will help you create images in lighting conditions that would be difficult to work with when shooting conventionally. You may therefore think that knowing about the basics of exposure would be unnecessary.

It's certainly true that HDR will help solve a lot of exposure problems, but it's still important to have a working knowledge of the strengths and weaknesses of your camera. There may be occasions when you are only able to shoot one image, rather than many, in which case how you expose that single shot will determine the quality of the HDR file you will subsequently be able to create.

Although digital cameras may seem like cutting-edge devices, the basic principles hark back to the beginnings of photography: controlling how much or how little light enters a camera was as important to the nineteenth-century photographer as it is to you. The way this is achieved—through the use of a variable aperture in the lens and a shutter—has changed in sophistication, but not in practice.

Where digital cameras far exceed their film brethren, is in the amount of information they convey about how an image should be exposed. Exposure meters and histograms are invaluable tools for assessing exposure, and learning how to use them correctly will improve all aspects of your photography, including your HDR images.

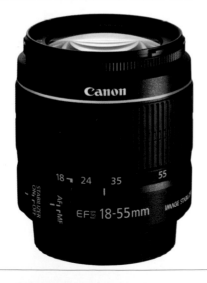

LENS CHOICE
The lenses you choose to use will determine the look of your images: zoom lenses with a relatively small maximum aperture are not ideal if you want to achieve a shallow depth of field, for example.

DYNAMIC RANGE *(Opposite)*
With practice it is possible to see immediately when a scene is suitable for HDR. The interior of this church was unevenly lit and I knew instinctively that the dynamic range exceeded that of my camera. So I bracketed three shots for blending later in post-production.

Canon EOS 7D with 50mm lens, three blended images at f/11, ISO 100

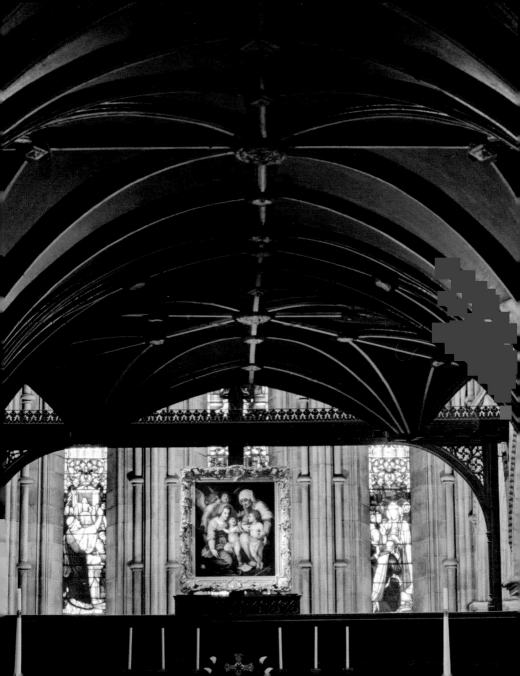

Exposure

To create an HDR image you first need to make a series of source exposures. Getting the exposure range correct at this stage will make your task a lot easier in post-production.

Taking control

There are two ways in which you can control how much or how little light reaches the sensor in your camera: the size of the aperture in the camera lens, and the period of time the shutter is open, allowing light to reach the sensor.

The aperture is a variable iris that has a range of adjustments from "maximum" (when the aperture is open at its widest), to "minimum" (when it is at its smallest). Prime lenses typically have larger maximum apertures than zoom lenses, and some zooms even have a variable maximum aperture that changes as you zoom in and out. The size of the aperture is measured in

f-stops, represented by f/ and a suffix number. A typical range of whole f-stops on a lens is f/2.8, f/4, f/5.6, f/8, f/11, and f/16. These are all fractions, so the greater the number after f/, the smaller the aperture.

The difference between each of the values in this sequence is known as a "stop," with each stop representing a halving of the amount of light let through the aperture as you make it smaller (or a doubling as you make it larger). For example, an aperture of f/5.6 will allow twice as much light through the lens as an aperture setting of f/8, but half as much light as f/4.

APERTURE
A lens at its maximum (left) and minimum (right) aperture setting.

Note

Some cameras allow you to vary the shutter speed and aperture in ½- or ¹/₃-stop increments: 1/40 sec. and 1/50 sec. are ¹/₃-stop increments between shutter speeds of 1/30 sec. and 1/60 sec., for example, while f/3.2 and f/3.5 come between f/2.8 and f/4 on the aperture setting.

The period of time the shutter is held open for is referred to as the shutter speed. The fastest shutter speed varies between camera models, but usually is around 1/2000 sec. to 1/8000 sec. The slowest shutter speed also varies: on most digital SLRs it is often 30 seconds, but on compact digital cameras it may be only one second, and frequently not even as long as that. Another useful feature (only found on digital SLRs) is the Bulb mode, which allows you to lock the shutter open by holding down the shutter-release button for as long as required.

Shutter speeds are varied on a camera by set amounts, such as 1/500 sec., 1/250 sec., 1/125 sec., 1/60 sec., and so on. As with the aperture, the difference between these shutter speeds is also referred to as a stop, with each stop representing either a halving (as the shutter speed gets faster) or a doubling (as it gets slower) of the amount of light that reaches the sensor. For example,

a shutter speed of 1/125 sec. allows twice as much light to reach the sensor as a 1/250 sec. shutter speed, but half as much light as a shutter speed of 1/60 sec.

Shutter speed and aperture

If you change either the shutter speed or the aperture on your camera, you must also change the other if you wish to maintain the same level of light hitting the sensor. If the aperture is opened up by a stop (from f/5.6 to f/4 for example), the shutter speed must be made faster to compensate. This is because the shutter speed and aperture have a reciprocal, interlinked relationship.

Shutter speed / Aperture

Shutter speed:

| 1/125 | 1/60 | 1/30 | 1/15 | 1/8 |

Aperture (f-stops):

| f/4 | f/5.6 | f/8 | f/11 | f/16 |

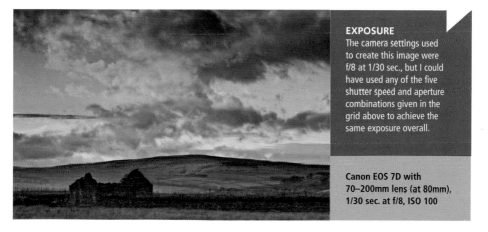

EXPOSURE
The camera settings used to create this image were f/8 at 1/30 sec., but I could have used any of the five shutter speed and aperture combinations given in the grid above to achieve the same exposure overall.

Canon EOS 7D with 70–200mm lens (at 80mm), 1/30 sec. at f/8, ISO 100

Depth of field

The sharpest part of an image is always at the point of focus. Sharpness is increased through the image space by the use of an optical effect known as depth of field, which is essentially a zone of sharpness that extends outward from the focus point, both toward the camera and away from it. There is always a greater zone of sharpness beyond the focus point than in front, but the actual size of the depth of field is governed by the use of the aperture: the smaller the aperture, the greater the depth of field.

In addition to the aperture setting, depth of field is governed by two other factors: focal length and camera-to-subject distance. Wide-angle focal lengths have greater inherent depth of field at any given aperture than longer focal length lenses, while the closer the focus point is to the lens, the less depth of field you have.

In close-up photography, for example, the focus point is very close to the lens so you will often have to use very small apertures to maximize the depth of field. Even then it can be difficult—or even impossible—to obtain front-to-back sharpness.

Depth of field is an important creative element in photography. A shallow depth of field, when everything is out of focus except for a very thin slice of the image, is an excellent way of simplifying a composition and directing the viewer to a particular point in the picture space. Conversely, a "deep" depth of field produces more naturalistic images, mimicking more closely the way in which we see the world.

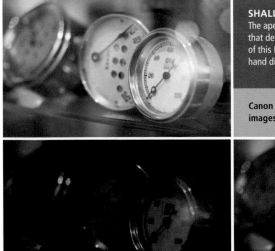

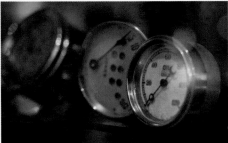

SHALLOW DEPTH OF FIELD
The aperture used for this shot was f/2.8. This meant that depth of field was extremely shallow. Because of this I focused precisely on the pointer on the right hand dial, which was the area I wanted to be sharp.

Canon EOS 7D with 50mm lens, three blended images at f/2.8, ISO 100

Depth of field and HDR

As you have already seen, it is very important to minimize the differences between each image when you are creating a bracketed sequence of exposures suitable for HDR. This is important to remember because, if you were to change the aperture to bracket your images, the depth of field will change. If you're shooting a landscape with a wide-angle lens this change may not be readily apparent, but if you are focusing particularly close to the camera or are using a long focal length lens, the change in aperture may have a significant impact on how each image in a sequence is recorded. Therefore it is far better to use the same aperture to record your entire image sequence and alter the shutter speed instead. This, however, may cause other problems, as discussed on the following page.

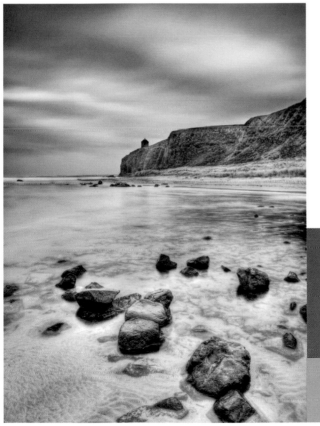

DEEP DEPTH OF FIELD
Landscape photographers often use small apertures to maximize the depth of field so that it stretches from the foreground to the horizon.

Canon EOS 1Ds MkII with 28mm lens, 20 sec. at f/18, ISO 100

Shutter speed

Pressing the shutter-release button on your camera opens the shutter to expose the sensor to light for a set amount of time (the shutter speed). If you were shooting a stationary subject you could potentially use any shutter speed you wanted, and it would be very unlikely that you would be able to tell the difference in the way the subject was recorded.

That all changes once your subject begins to move. At that point, the shutter speed you choose will determine how your subject is recorded in the image. The faster the movement, the faster your shutter speed will need to be in order to "freeze" the action, while the slower the shutter speed, the more blurred your moving subject will become. With a sufficiently long shutter speed you may even find that your subject leaves only a faint, ghostly trail or disappears entirely.

Another factor that could influence your choice of shutter speed is whether your camera is being handheld or mounted on a tripod. The slower the shutter speed, the greater the risk of camera shake, and the general rule is that the shutter speed should be equal to or faster than the focal length you are using. So, if you're using a 50mm focal length, use a shutter speed of 1/50 sec. or faster, a 400mm lens needs 1/400 sec. or faster, and so on. Most cameras are programmed to "know" this rule, so when they are used in automatic shooting modes such as Program, they will try to prioritize the shutter speed.

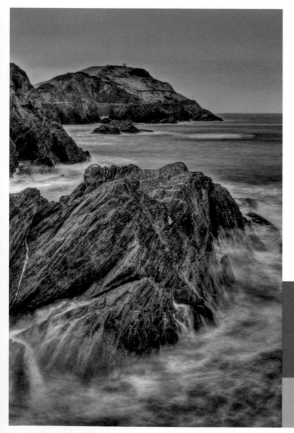

SLOW
Using slow shutter speeds when there is movement in a scene can be very effective. I deliberately used the slowest shutter speed I could for this image so that I got a sense of the waves washing over the rocks.

Canon EOS 7D with 17–40mm lens (at 40mm), 6 sec. at f/16, ISO 100

Using a camera or lens with image stabilization will make it easier to handhold a camera at slower shutter speeds, but don't forget that this may not prevent your subject from blurring if they are moving!

Slow shutter speed and HDR

The smaller the aperture you use (to increase the depth of field), the slower the shutter speed will be. If the scene you are photographing is well lit, that might not be a problem, but when the light levels are low you may find that the required shutter speed is an appreciable fraction of a second, sometimes many seconds, or even minutes. When shooting moving subjects for HDR this can make life very difficult, as the scene will invariably change from frame to frame over the sequence of images. To make matters worse, if your shutter speed is longer than 1 second, your camera may well apply long-exposure noise reduction, which effectively doubles the length of the exposure.

In this situation you have several options. One option is to shoot a single frame and use that to create an HDR image. This isn't ideal, but is certainly possible, particularly if you "expose to the right" to maximize the usable information in the image. A second option is to increase the ISO, which will allow you to use a faster shutter speed while maintaining the required aperture. Again, there are compromises to this approach, as increasing the ISO will increase visible noise in the image. Finally, you could shoot at the required shutter speeds, but be prepared for a certain amount of work when you merge your sequence to remove ghosting

from your images. There is no one ideal solution to the problem of ghosting, so it is ultimately up to you and the capabilities of your camera as to which solution is the best.

FAST
Subjects such as flowers, which move in the wind, invariably require a fast shutter speed to be used. This will mean using a larger aperture (or increasing the ISO), so precise focusing is important.

Canon EOS 1Ds MkII with 100mm lens, 1/250 sec. at f/4, ISO 400

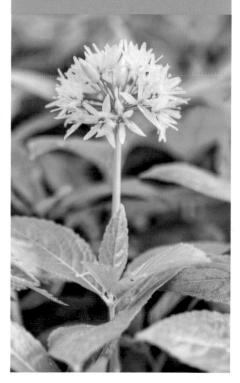

Camera: Canon EOS 1Ds MkII
Lens: 17–40mm (at 35mm)
Exposure: Three blended
images at f/11
ISO: 100

COMPROMISE

This was an image where I could either have used a graduated filter (diagonally across the top right of the scene) or shot an HDR sequence. Both options involved a compromise—shooting HDR was problematic as there was a lot of movement in the scene. However, this is the option that I ultimately went for. The use of the Photomatix Pro's deghosting feature helped to deal with problematic areas such as the wind-blown tree in the top left corner.

Camera: Canon EOS 7D
Lens: 17–40mm (at 35mm)
Exposure: Four blended images at f/11
ISO: 100

FLARE
Shooting into the light means dealing with extreme levels of contrast. HDR can, of course, be used to cope with this, but avoiding flare is more difficult. In this shot I found a position that hid the sun behind the branches of the distance trees. Even so, there is still some flare visible in the image.

Exposure and metering

The exposure meter in your camera is a marvelous instrument, but it is not infallible. Understanding how it works will help you plan your HDR images more successfully.

How much light?

The exposure meter in your camera is a reflective meter, so called because it measures the amount of light that is reflected back from the scene. Although reflective meters are usually accurate, they can be fooled by the reflective qualities of the scene being metered. Reflective meters "assume" that the scene being measured reflects an average of 18% of the light that falls onto it. That's the same amount of light that a matte mid-gray surface would reflect, and grass, stone, and a cloudless blue sky (approximately 90° to the sun) all equate roughly to this ideal 18% reflectivity.

Problems with metering occur when the level of reflectivity of a scene deviates from the average. Reflective meters are often fooled when there are darker or light tones in a scene, for example. When light tones dominate

a scene, the camera's meter will try and compensate, often resulting in underexposure. Conversely, the meter will try and overexpose a scene when there are more dark tones than average. In both instances this happens because the meter is trying to pull the exposure back to that mid-gray 18% ideal.

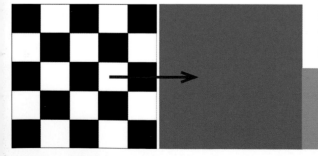

CHECKERBOARD
A reflective meter would correctly expose this checkerboard because there is an equal number of black and white squares, which average out to a perfect mid-gray.

Camera: Canon EOS 5D
Lens: 17–40mm lens (at 40mm)
Exposure: 1/400 sec. at f/11
ISO: 100

WINTER
Snow scenes are prone to underexposure because light tones dominate. This scene required -1½ stops of exposure compensation to get the correct result.

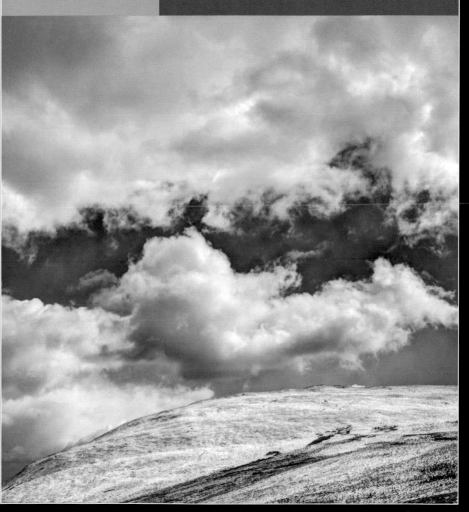

The histogram

The LCD screen on the back of your camera isn't an accurate way to assess whether an image has been exposed correctly. So how do you know whether you've achieved the correct exposure?

A graphic representation

A quick glance at the LCD on the back of your camera may suggest that an exposure looks fine, but is it? Ambient light shining onto the screen can easily fool you into misreading how bright or dark your image actually is, while all images appear brighter on the LCD screen in low light conditions. Fortunately, cameras come equipped with a better tool for assessing exposure—the histogram.

A histogram is a graph that shows you the distribution of tones in your image. From left to right the horizontal axis represents the full potential range of tones in an image, from black through to white (with the mid-tones fittingly in the middle). The vertical axis shows the number of pixels in the image that correspond to a particular tone.

If the histogram is pushed too far to the left or right, so that the graph is right up against the wall of the surrounding box, it is described as being "clipped." This means that there are pixels in your image that are either pure black or pure white. Once a pixel has reached that point there is effectively no detail being recorded, and no matter how you adjust your image during post-processing, you will not be able to recover that detail. Cameras often show this is happening by "blinking" the affected areas in the image on the LCD. If you intend to "expose to the right" (see page 80), the histogram is an invaluable tool, so learn to read it well.

(Top) The shadow areas in this histogram are clipped, indicating a loss of detail in the darkest areas.

(Middle) The tonal range is better distributed in this histogram, with no clipping at either end.

(Bottom) The highlights in this histogram have been clipped, indicating a loss of detail in the brightest part of the image.

> *Note*
>
> *If you're bracketing a sequence of images, check the histograms of the lightest and the darkest to make sure that neither the highlights nor the shadows are clipped. If they are, you will need to extend the range of exposures you are shooting.*

Checking white balance

The histogram described so far has been a luminance histogram, which shows the range of brightness in an image (as though the image had been converted to black and white). Some cameras, however, can also show an RGB histogram, which reveals how the red, green, and blue channels have been exposed.

RGB histograms are invaluable if you want to check that the white balance of your image is correct. First, set your camera to display an RGB histogram and then take a photo of a white or gray surface in the same light as your subject. The surface must be completely neutral in color, otherwise the results will be skewed. If your white balance is correct, the red, green, and blue components of the histogram should be aligned. If they are not, the white balance is most likely incorrect.

To correct the white balance, you would need to use a setting that "cools" the image down if the red peaks in the histogram are skewed to the right, or "warms" it up if the blue peaks are shifted to the right.

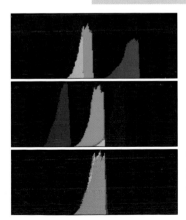

(Top) This RGB histogram is showing that the white balance is too cool...

(Middle) ...Whereas this histogram indicates it is overly warm.

(Bottom) This histogram is just right, indicating that the white balance is neutral for that particular light source.

Exposing to the right

If you're shooting RAW files, the exposure suggested by your camera isn't necessarily the one that will optimize the amount of usable image data. Because of the way that a digital sensor records light, more information is gathered for the lighter tones than is gathered for the dark tones. Shooting a sequence of images for HDR takes advantage of that fact,

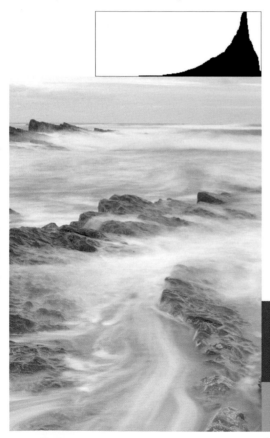

because the "overexposed" image(s) lightens the shadows, increasing the amount of data captured there.

If you can only shoot one image for conversion to HDR, then it's better to set the exposure so that the image recorded is as light as possible, without the highlights being clipped. This can be done either in manual exposure and ignoring the suggested exposure reading, or by applying exposure compensation. Exposing the image in this way will maximize the amount of data gathered across the tonal range. This will invariably make the image on the LCD screen appear washed out, and your histogram will also be skewed to the right—this is the most useful way of checking that the technique is working and the reason why this technique is called "exposing to the right."

When you process the image, this initial exposure will be the lightest in the sequence you'll create. Save this exposure as a TIFF. You'll then need to reprocess the file, decreasing the exposure in your RAW conversion software, and saving it out as another TIFF with a different file name. Repeat again if you want to darken the image still further. Once you've done that, you can combine the TIFFs into an HDR file.

WASHED OUT
This is an image that I "exposed to the right," along with its associated histogram. Although the image appears flat and overexposed, it's an excellent starting point for creating a single-shot HDR image.

Canon EOS 7D with 50mm lens, 2 sec. at f/18, ISO 100

Exposure compensation

Cameras aren't infallible, and you will find that the exposure recommended may not always be the ideal starting point for a sequence of HDR images. If you're using Program, Aperture Priority, or Shutter Priority shooting modes then you will be able to use exposure compensation to override the suggested exposure. The amount of exposure compensation you can apply varies between camera models, but is typically ±3 stops (usually in ½- or ⅓-stop increments). If you are automatically bracketing your shots, then the sequence will be centered on the compensated exposure value, with adjustments made either side of that.

A camera with Live View should show you the results of exposure compensation immediately on the rear LCD screen, and it may even display a live histogram that will confirm that the exposure has changed (the histogram should move to the left if you're applying negative exposure compensation, and to the right for positive compensation).

RAW
If you adjust the exposure of a RAW file in your conversion software, you are effectively applying exposure compensation. However, doing this— particularly if you are lightening an image—will increase the likelihood of noise. If you are creating single-image HDR files this is a necessary process.

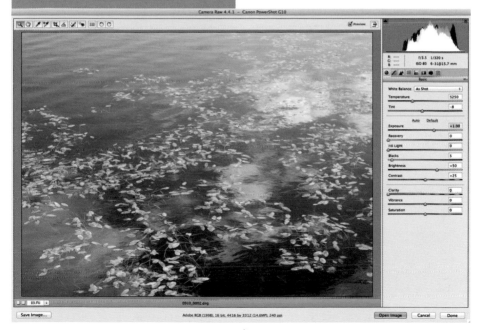

The Expanded Guide | **81**

Metering for ND grads

There are two methods you can use to determine whether you'll need to use an ND graduate filter to retain detail in an area of an image, and these methods could also be used to work out the bracketing range you would need to use to capture the full tonal range of a scene.

The first is relatively simple but crude. Switch your camera to manual exposure and center-weighted metering. Point your camera down toward the foreground and set the required aperture and shutter speed combination determined by the meter reading. Next, point your camera toward the sky. The suggested meter reading will change. Note the difference and select an ND graduate that will reduce the difference to just 1 stop. For example, if the difference between the foreground and sky were 3 stops, you would use a 2-stop (or 0.6) ND graduate filter. Add the filter to your lens and then use the original meter reading set for the foreground. Of course, if the difference is already 1 stop when you meter both parts of the scene, you don't need a filter.

The second method requires your camera's spot meter and is slightly more accurate. First, take exposure readings from the midtones in your image, such as grass or rocks. Note the suggested exposure and take meter readings for the highlights. The highlights should be 2–3 stops brighter than the midtones. If they exceed this range, a filter is needed, or your bracketed sequence needs to be extended to make sure that highlight detail is retained. Now, do the same with the shadows. Shadows can't be filtered, of course, but the difference between the exposure for the midtones and the shadows will help you decide on the bracketing range.

— SHADOWS

— HIGHLIGHTS

— MIDTONES

METERING
The three points that I took exposure readings from in this scene indicated that I needed to use a 3-stop ND graduated filter.

Canon EOS 7D with 17–40mm lens (at 28mm), 1/200 sec. at f/6.3, ISO 100

SPOT METER *(Opposite)*
Careful metering from the sunbeams, cloud, and foreground rock helped me to determine the bracketing range needed to capture the full dynamic range of this dramatic scene.

Canon EOS 7D with 50mm lens, three blended images at f/14, ISO 100

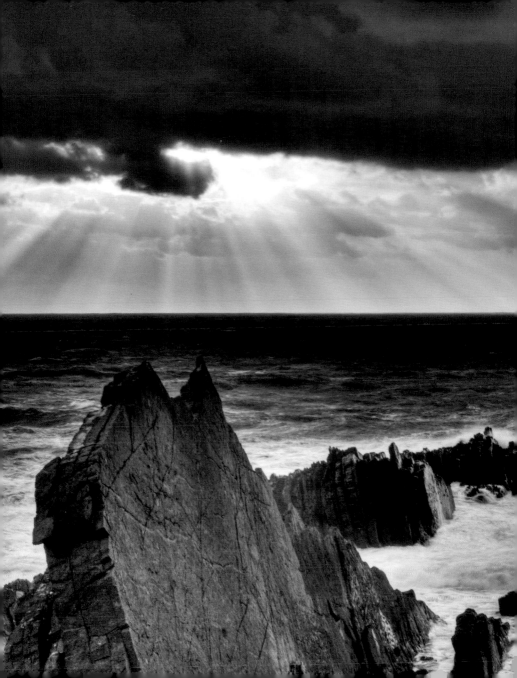

ISO and noise

The aperture and shutter speed settings you use control the amount of light that enters the camera. However, you can also adjust how "sensitive the sensor is to light and adjust the exposure that way as well.

ISO

As with the aperture and shutter speed, ISO is set in stops (although most cameras allow you to set ISO in ½- or ⅓-stop increments as well). The base ISO—the ISO setting where the sensor is least sensitive to light—varies from camera to camera, but is usually somewhere in the range of ISO 80–200. The highest ISO setting also varies and can be anywhere from ISO 800 on older digital cameras to ISO 204,800 on recent models, although this is frequently increasing as technology improves.

Using a higher ISO will allow you to use a faster shutter speed or a smaller aperture as light levels drop. This is useful when you are handholding your camera and want to minimize the risk of camera shake. However, there is a drawback to using a higher ISO: when the ISO is raised, image "noise" increases with it.

Note

Some cameras have ISO settings that are lower than the standard base ISO. These are special settings that provide a lower ISO by compromising on the dynamic range of the image. This can be problematical for "normal" shots, but the dynamic range compromise is less of a problem when bracketing for HDR.

When shooting for HDR, avoid using Auto ISO. You want your bracketed images to be as consistent as possible, without the ISO changing between the exposures, so set it manually.

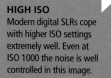

HIGH ISO
Modern digital SLRs cope with higher ISO settings extremely well. Even at ISO 1000 the noise is well controlled in this image.

Noise

There are two types of digital image noise, luminance and chroma, and they are caused by either the use of a high ISO or a long exposure. In both cases they reduce fine detail, but this is done in slightly different ways. Luminance noise can make an image appear "gritty," and most closely resembles film grain, while chroma noise results in unsightly blotches of color, that are particularly unwelcome when shooting portraits.

Noise can be controlled by the use of noise-reduction software, but over-use of this can make images appear artificial and surfaces look too smooth. Of the two types of noise, chroma noise is the more difficult to reduce successfully.

When it occurs, noise is most noticeable in the shadow areas of images, particularly if an image is lightened during post-processing. In standard photography this can be a problem, especially if you haven't exposed to the right, but if you are bracketing your photos with the intention of creating an HDR blend you should be exposing for the shadows with at least one of the bracketed images. This should reduce the amount of visible noise due to any increase in ISO.

Where noise may be a problem is if you are using particularly long exposures. Most cameras have an option to reduce long exposure noise, but this works by shooting a second, blank frame for the same length of time as the first exposure. This doubles the length of time that a single image requires for the exposure and processing, which exacerbates the problem of ghosting when shooting HDR sequences. It is therefore recommended that you turn this off and deal with long exposure noise in post-production.

NOISE REDUCTION
Dedicated noise reduction software such as PictureCode's Noise Ninja is available either as a standalone application or as a Photoshop plug-in.

Depth of field

When shooting a sequence of images for HDR, any difference in the depth of field of the images can result in ghosting. For this image I set the focus point and then locked it. I then set the camera to Aperture Priority so that only the shutter speed would change when I bracketed the shots. As I was using a large aperture, any change in depth of field between shots would have been apparent immediately.

Camera: Canon EOS 7D
Lens: 50mm lens
Exposure: Four blended images at f/3.5
ISO: 100

Metering

Using your camera's spot meter allows you to quickly assess the dynamic range of the scene in front of you. The greater the dynamic range, the greater the spread of your bracketing—and potentially the greater the number of images you will need to shoot to cover the entire dynamic range.

Camera: Canon EOS 7D
Lens: 70–200mm lens
(at 70mm)
Exposure: 1/125 sec.
at f/11
ISO: 100

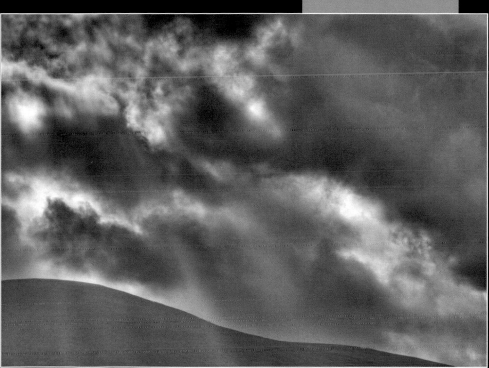

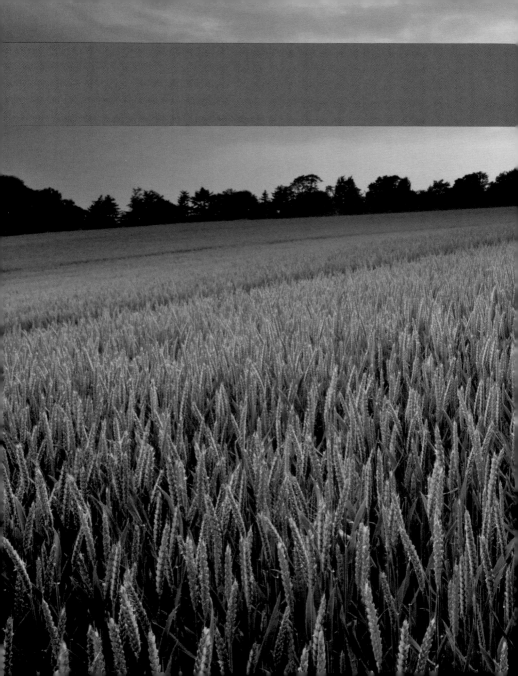

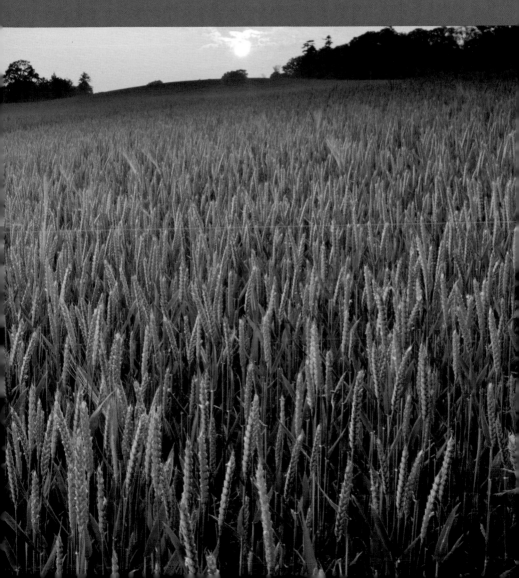

CHAPTER 4 SHOOTING FOR HDR

Introduction

Although shooting for HDR doesn't require any more skills than "straight" photography, there are a few more items that must be ticked off your mental checklist as you are working.

Everyone has his or her own way of working and it is good practice to develop a routine that works for you as soon as possible. This doesn't mean that you need to work mechanically, only that consistency will enable you to think

APERTURE PRIORITY
My "standard" way of working is to use Aperture Priority so that I can control the depth of field, and ISO 100 for maximum image quality.

Canon EOS 7D with 17–40mm lens (at 25mm), two blended images at f/11, ISO 100

more about the creative process rather than the purely technical details.

Methods of working include such simple tasks as keeping your camera bag tidy and consistently packed. When you reach a location it's good to have all of your equipment in a familiar place and at hand so that there is no time wasted searching for a vital piece of kit. At the end of a shoot, resetting your camera to a standard (to you) series of settings is useful also. This means that the next time you pick your camera up it won't be in the wrong mode without you realizing. It's probably happened to every photographer at some point, but is easily avoided!

Of course, having standard settings implies a familiarity with your camera, and this is probably the most important aspect of photography. If you don't know what mode you should be in at any given time then it will difficult to make the most of any opportunities that arise. Fortunately digital cameras are ideal tools for experimenting with, as each shot is essentially free. So, really, there's no excuse!

CONTRAST *(Opposite)*
The contrast in this scene far exceeded the dynamic range of my camera by a considerable amount, making this an ideal candidate for an HDR treatment.

Canon EOS 7D with 17–40mm lens (at 40mm), three blended images at f/11, ISO 100

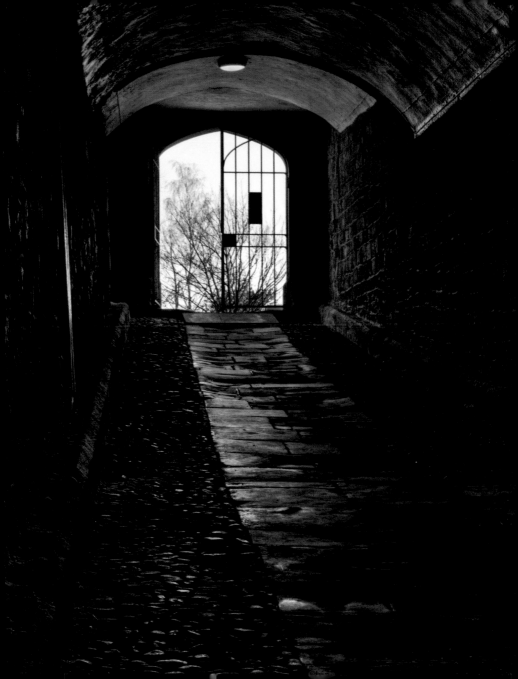

Setting up the shot

You've found the ideal composition for your image, your camera is on a tripod, and you're itching to press the shutter-release button. So what do you do next?

Camera controls

Cameras have a number of options for setting the exposure. The first to discount are modes that are entirely automatic: any camera control that locks you out of making adjustments will not work for HDR. Automatic modes are often referred to as Scene modes, which are modes optimized for specific shooting situations, such as portraits or landscapes.

The semi-automatic shooting modes on your camera are more suitable. These are usually Program, Aperture Priority, and Shutter Priority (labeled as P, A [or Av], and S [or Tv] respectively). Of the three, Program is the least flexible, as the camera will select the aperture and shutter speed for you. However, you can usually override these settings to select the

desired combination (see your camera manual for details). Program will also let you use exposure compensation and automatic exposure bracketing. What you may not have control over is whether it is the shutter speed or aperture that is altered during the bracketing process.

For that reason, it is preferable to use either Shutter Priority or Aperture Priority when you record your HDR sequences. Both modes will give you a choice of whether you set the shutter speed (in S/Tv) or the aperture (in A/Av): when you bracket, it is the opposite exposure control that is adjusted during the bracketing process.

The one problem with automatic bracketing in these modes is that there is usually a limit of ±3 stops adjustment. If there is excessive contrast that exceeds this ±3 stop range then you need to use Manual exposure (M) as this will allow you to under- and overexpose by a much greater margin, simply by adjusting the shutter speed.

SHOOTING MODE
The shooting mode you choose will determine how easy it is to shoot multiple exposures for HDR.

Assessing the scene

The level of contrast in the scene will determine how many bracketed images you need to make in order to capture the full tonal range. It's tempting to fire away and bracket seven, nine, or even eleven shots, but in practice most scenes don't require anywhere near that number and the more images you merge, the longer the process will take. Shooting sparingly will therefore save time both during the shoot and during post-processing, as well as saving space on your memory card. Typically most outdoor scenes will only require three bracketed exposures at ±2 stops.

A situation where it's likely that you'll need to shoot more individual images is when you're indoors with windows revealing a bright exterior. The contrast range in this situation will be high (unless the interior is brightly lit), which may mean that making five exposures across a ±4 stop range may be required.

However, most cameras don't allow you to bracket more than three images, so what do you do? One option is to bracket as normal, then set the exposure compensation to -2 stops and bracket again. Finally, set the exposure compensation to +2 stops and bracket once again. The drawback with this approach is that there will be an overlap in exposures, but the duplicates are easily deleted. The second option is to shoot manually and adjust either the shutter speed or aperture (and be consistent) until you've covered the full brightness range for your sequence.

INTERIOR
The dynamic range of this scene meant bracketing across ±3 stops was required.

Canon EOS 1Ds MkII with 17–40mm lens (at 24mm), three blended images at f/11, ISO 100

> ### Note
> The number of shots you take will also depend on the exposure difference between your bracketed shots. If the difference is ±2 stops, then you may only need to shoot three images, but if the difference were ±1 stop you would need to take five images to cover the same range.

Camera: Canon EOS 7D
Lens: 70–200mm lens (at 200mm)

Exposure: ½ sec. at f/8, ISO 200
Exposure compensation: -2⅔

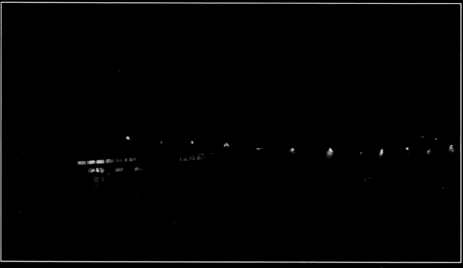

Exposure: 2 sec. at f/8, ISO 200
Exposure compensation: 0

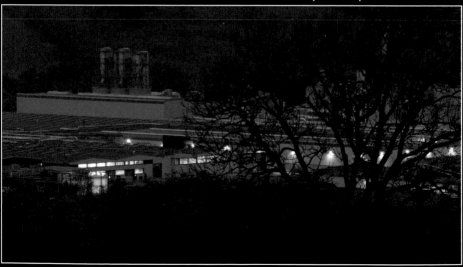

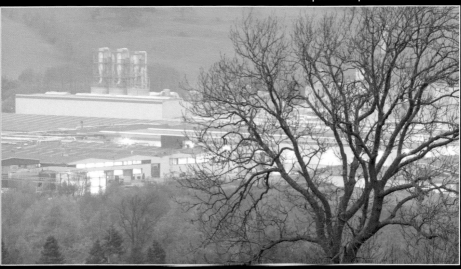

Exposure: 10 sec. at f/8, ISO 200
Exposure compensation: +2⅔

The final image, blended using
Photomatix Pro's Fusion method.

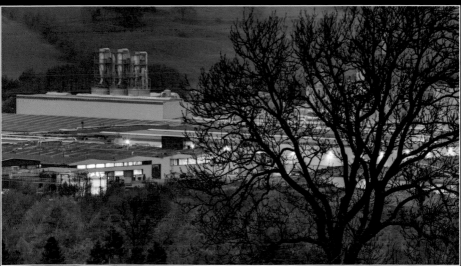

Flash

HDR and flash may not seem likely bedfellows, but by following a few simple principles, flash will help you to get the optimum exposures you need for HDR.

Guide numbers

Whether you use your camera's built-in flash or an external unit, the amount of light it produces will be relatively weak. The maximum power output of a flash is measured as a numerical value, which is known as the guide number (or GN). The GN is given in meters or feet for a specific ISO sensitivity and this allows you to calculate the flash's range. The average guide number for a built-in flash is 40 feet (12 meters), but if the ISO on a camera is altered, the GN changes: the higher the ISO, the greater the range of the flash, and therefore the higher the GN.

To avoid confusion the majority of manufacturers use ISO 100 as a standard value when quoting a flash guide number. This can be used to determine the aperture value needed to correctly expose a subject at a given distance (or calculate the effective range of the flash at a chosen aperture). The formula to calculate these is:

GN/distance=aperture
GN/aperture=distance

So, for example, if a flash has a GN of 131 feet (40 meters) at ISO 100, with an aperture setting of f/8 (and the camera set to ISO 100), the effective flash distance would be 16.38 feet

Effective flash distance for a flash with GN 40(ft)/GN 12(m) at ISO 100							
	Aperture						
ISO	f/2.0	f/2.8	f/4	f/5.6	f/8	f/11	f/16
100	6m	4.29m	3m	2.14m	1.5m	1.09m	0.75m
	19.68ft	14.07ft	9.84ft	7.02ft	4.92ft	3.58ft	2.46ft
200	8.49m	6.06m	4.24m	3.03m	2.12m	1.54m	1.06m
	27.85ft	19.88ft	13.91ft	9.94ft	6.95ft	5.05ft	3.48ft
400	12m	8.57m	6m	4.29m	3m	2.14m	1.5m
	39.37ft	28.12ft	19.68ft	14.07ft	9.84ft	7.02ft	4.92ft
800	16.97m	12.12m	8.49m	6.06m	4.24m	3.03m	2.12m
	55.67ft	39.76ft	27.85ft	19.88ft	13.91ft	9.94ft	6.95ft
1600	24m	17.14m	12m	8.57m	6m	4.29m	3m
	78.74ft	56.23ft	39.37ft	28.12ft	19.68ft	14.07ft	9.84ft

(5 meters). If the ISO on the camera is doubled, the effective flash distance is multiplied 1.4 times so, at ISO 200, and still at an aperture of f/8, the effective flash distance increases to 23.16 feet (7.07 meters).

Sync speed

When using flash, the fastest shutter speed that you can set is known as the synchronization speed (or sync speed). This is usually somewhere in the region of 1/250 sec. Your camera will probably not allow you to set a higher shutter

speed than this until the flash is switched off. However, this does not mean that you have to use 1/250 sec. In low light you could use a slower shutter speed to expose the background correctly, while leaving the flash to illuminate your subject. This is known as slow sync flash.

When using a flash, manually adjusting the lens aperture controls the effective flash distance. If your subject is further than the effective flash distance for the set aperture, the subject will be underexposed. If the subject is closer than the effective flash distance you will need to reduce the flash output using the controls on the flash, close the aperture further to reduce the effective flash distance, or alter the ISO setting.

Slow sync flash

As mentioned above, the fastest shutter speed you can use with flash is the camera's sync speed. When the ambient light level is low, you may find that this shutter speed is too fast to allow the background to be exposed correctly. This results in your subject being perfectly exposed, but the background is dark and dingy.

Using the correct shutter speed necessary for the background solves this problem, and is also the key to using flash with HDR. If you want to shoot a series of images for HDR with flash, then bracket the shutter speed and not the flash output (and don't change the aperture either, as this controls the effective range of the flash). However, when the light levels are low, the length of the shutter speed will increase and the more risk there will be of camera shake. At this point it is recommended that you use a tripod.

INTERIOR
This is a blend of two images, both shot at f/11 using flash. The difference was in the shutter speed—the shutter speed of the second image was longer, in order to expose the background more effectively.

Canon EOS 1Ds MkII with 17–40mm lens (at 28mm), two blended images at f/11, ISO 100

Metering and white balance

Cameras have two key settings that you need to familiarize yourself with for HDR: the built-in exposure meter and white balance.

Evaluative

Evaluative (or Matrix) metering is usually the default setting on a camera. It works by splitting the scene being metered into a series of cells or zones. Each cell is metered individually and the final exposure is calculated by combining the results from all of the different cells. Some systems will bias the metering to the point of focus, to help make sure that the subject (which it is assumed is being focused on) is exposed correctly. Evaluative metering is usually very accurate, but it can be fooled when ND graduated filters are used. In this case it is better to set the exposure for the foreground before fitting the filter.

Center-weighted

This method of metering pre-dates evaluative metering by many years and was once the standard option on manual 35mm film SLR cameras. As with the evaluative metering pattern, center-weighted metering also assesses the entire scene, but it biases the exposure to the center of the image, based on the assumption that the main subject will tend to be placed centrally. How large the bias is varies between camera models. Although evaluative metering has largely superseded center-weighted metering, the latter is still a useful setting to help you expose correctly for backlit subjects.

Spot metering

This metering mode measures a very small section of a scene, allowing you to assess individual elements. The size of the spot metering area varies between camera models, but is typically 1–5% of the entire image area.

White balance

Most light has a color bias, which is usually either orange-red (resulting in the light appearing "warm") or blue (which is a "cool" light). Unless it is extreme, we tend not to notice this color bias, as our eyes and brain adjust so that it appears neutral. This variation in the color bias of light is known as a variation in the color temperature, measured using the Kelvin scale (K).

Cameras will faithfully record any color bias in a scene unless steps are taken to neutralize it. This process is known as white balancing. Digital cameras have presets for a number of different types of light, and if you are shooting RAW files you will also have the option to adjust the white balance after capture (both Photoshop and Photomatix Pro have tools for adjusting the white balance before RAW images are merged to HDR). However, if you're shooting JPEG it's important to get the white balance correct at the time of capture. Although there are subtle variations between cameras, the symbols for the various presets are shown below:

KEY SYMBOLS	
AWB	Automatic white balance
☀	Daylight (normal sunny conditions)
⌂	Shade (when shooting in shadow)
☁	Cloudy (adds warmth on overcast days)
💡	Incandescent (indoor domestic lighting)
▦	White fluorescent lighting (indoor fluorescent lighting)
⚡	Flash (use with electronic flash)
◤●◢	Custom white balance

Black and white

Black-and-white HDR images can look impressive, but the black-and-white conversion is best achieved in post-processing. This is particularly true if you are shooting JPEGs to create your HDR images. Once an image has been saved in-camera as a black-and-white JPEG, there is no restoring the color!

Camera: Canon EOS 7D
Lens: 50mm lens
Exposure: 1/160 sec. at f/9
ISO: 200

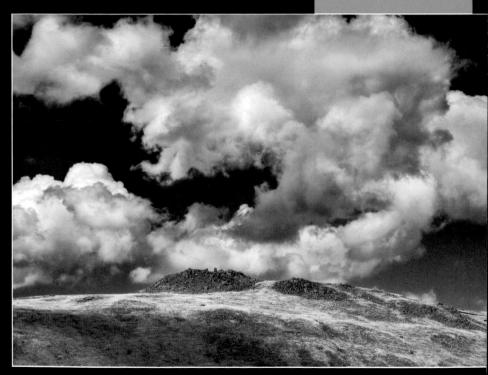

Kneeling down

Looking down on your subject (either literally or metaphorically) is rarely a good thing. For images such as this I prefer to get down to the same level as the subject, even if it means some level of personal discomfort. However, being uncomfortable is fleeting, whereas a successful image is forever.

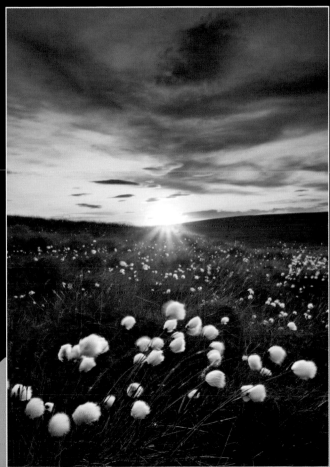

Camera: Canon EOS 7D
Lens: 17–40mm lens (at 20mm)
Exposure: Three blended images at f/14
ISO: 100

CHAPTER 5 HDR CONVERSION

Introduction

Once you've shot your images you need to process them to create an HDR merge. This chapter covers the basics of using Photoshop and Photomatix Pro to do just that.

Tone mapping, the science of reducing the tonal information in an HDR image so that it can be reproduced on an LDR device, is an ongoing quest for perfection. There is no such thing as an ideal method of tone mapping. However, technology is improving constantly and new methods are being developed all the time. The two pieces of software covered in this book represent two different, if similar, approaches to this science.

Photography isn't just about science of course. It's also about art and self-expression. HDR is a marvellous tool to achieve just this. Search for HDR on a web site such as Flickr and you will find thousands, if not hundreds of thousands, of HDR images. It's probably fair to say that the vast majority of them were created using Photoshop or Photomatix Pro, but the job isn't finished after you've created your HDR image: the chapter after this explores the ways in which your masterpiece can be polished to perfection.

MONOCHROME
Photomatix Pro allows you to create color or black-and-white HDR images.

Canon EOS 1Ds MkII with 70–200mm lens (at 200mm), three blended images at f/11, ISO 100

ATMOSPHERE *(Opposite)*
HDR doesn't just have to be about vivid colors; the technique can also be used to produce atmospheric images that rely on a relatively restrained palette.

Canon EOS 1Ds MkII with 17–40mm lens (at 35mm), three blended images at f/11, ISO 100

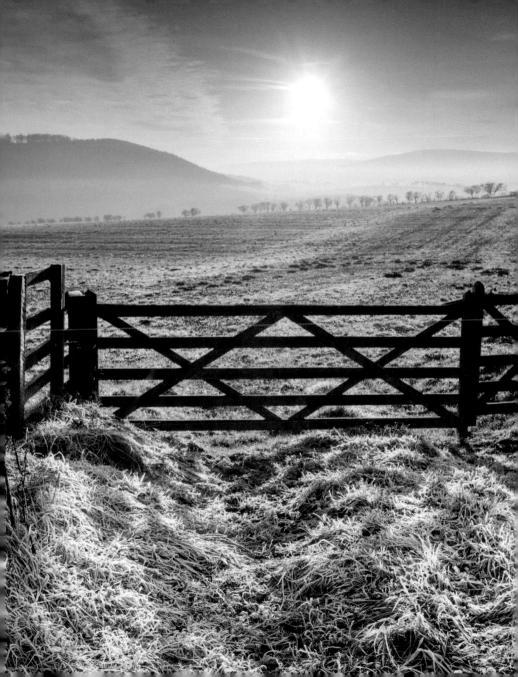

Adobe Photoshop

The addition of HDR to Photoshop is relatively recent, but it makes for a complete HDR solution: once you have created your HDR image you can use Photoshop's full range of editing tools to refine it.

Creating an HDR merge

The starting point is to select *File>Automate> Merge To HDR* from the main menu. You can either use images that are already open in Photoshop by clicking *Add Open Files*, or you can load them directly from your computer's hard drive by clicking *Browse*. Once the images have been selected, click *OK* to continue.

When Photoshop has assessed your photos, it will display a dialog box. The main image in the center is a very quick composite of the images you've chosen to merge. Don't worry if this doesn't look right initially. At the right is a histogram showing the distribution of tones in the image. Each red line below the histogram represents a difference of one stop in exposure and you can change the white point of this image by dragging the slider below the histogram at the right. At the left of the window are thumbnails of all the images used. If at this point you wish to remove any of the exposures from the final HDR image, uncheck the photo. Once you are happy with all the changes you have made to the settings, click *OK* to merge the photos and create your HDR image.

Notes

If you see the message "There is not enough dynamic range in these photos to construct a useful HDR image," there is not enough difference in the images you have selected to construct a successful HDR blend.

Converting to 16-bit

Once Photoshop has created the HDR merge, you will be returned to the main Photoshop workspace with your 32-bit HDR image open on screen. Although there are options in Photoshop to edit the image in this form, to access the majority of Photoshop's tools you will need to convert the image to 16-bit.

To make this change, select *Image>Mode> 16bits/Channel.* You will be presented with a dialog box offering four conversion methods as outlined below and opposite. Some of the methods can be refined by the use of sliders or, in the case of Local Adaptation, by using a tone curve. If you'd like to save the adjustments to apply them to other images click *Save*. To reload the settings click on *Load*. Once you're happy with the method you've chosen, and any adjustments you've made, click *OK* to continue.

Exposure and Gamma

This option is similar to Photoshop's Brightness/Contrast adjustment tool. Use the sliders to adjust manually the *Exposure* (brightness) and *Gamma* (contrast) of your HDR image.

Highlight Compression

The contrast of the highlight areas is reduced to create an image with a tonal range more suited to 16- or 8-bit. This option is fully automatic and no alterations can be made.

Equalize Histogram

The dynamic range is compressed to create an image with a tonal range more suited to 16- or 8-bit, but with the contrast preserved as much as possible. As with Highlight Compression, this option is fully automatic, so no alterations can be made.

Local Adaptation

This conversion method is initially the most complicated, but once you understand how it works it will give you greater flexibility in the look of your HDR images. Local Adaptation exploits the way that our vision works by "tricking" it into seeing more contrast in the HDR image than there actually is.

The *Radius* slider adjusts the size of local brightness regions in the image, while the *Threshold* slider sets how sensitive the *Radius* slider is. It does this by altering how far apart the tonal values of two pixels must be before they're no longer regarded as being part of a local brightness region.

A high *Threshold* value increases local contrast, but also increases the risk of distracting "halo" artifacts appearing in your image. This is less likely to happen when a low *Threshold* value is set, but your image can then start to look flat and washed out. Different photos will require different *Radius* and *Threshold* settings, and only experimentation will allow you to judge what those settings are.

Finally, a *Curve* tool allows you to make further adjustments to the brightness and contrast of your HDR image before you create the final conversion.

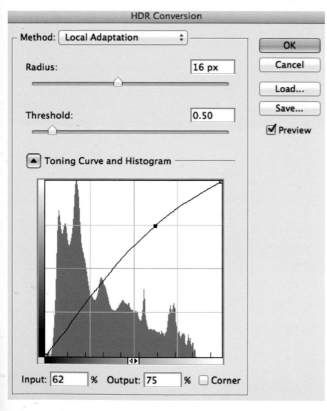

REAL LIFE *(Opposite)*
Photoshop's Local Adaptation method is well suited to producing naturalistic images such as this interior.

Canon EOS 1Ds MkII with 17–40mm lens (at 24mm), three blended images at f/14, ISO 100

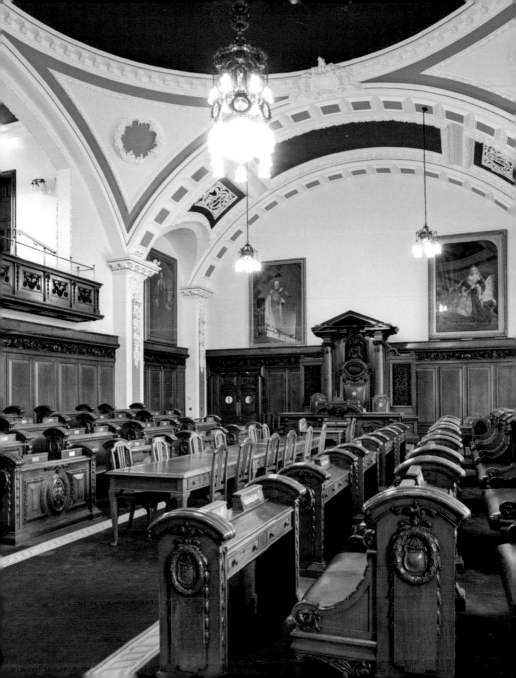

Camera: Canon EOS 1Ds MkII
Lens: 17–40mm lens
(at 40mm)
Exposure: Two blended images at f/16
ISO: 100

WARMTH

This image is "warm" in color, with an overall yellow/orange cast. This could have been corrected by adjusting the white balance when the shot was taken, but the warm tone helps to convey the idea of comfort and that this is a room that it would be pleasant to spend time in.

Camera: Canon EOS
1Ds MkII
Lens: 50mm lens
Exposure: Two blended
images at f/16
ISO: 100

COOL

Color has an important part to play in how an image is perceived. This image is predominantly cool blue. I could have altered the white balance so that it was more neutral, but this would have reduced the feeling that night was falling, and stormy weather was closing in.

Photomatix Pro

Currently at version 4.1.1, Photomatix Pro is a highly regarded HDR image creator. The rest of this chapter is devoted to explaining how to make your first HDR images using it.

Creating an HDR merge

Using Photomatix is very straightforward, as it doesn't have the bewildering range of features found in Adobe Photoshop. This is hardly surprising, though, as Photomatix is devoted solely to the creation of HDR images, with only the controls you'll need to achieve this.

Once an image has been processed, you'll work using the various option palettes that are displayed automatically. The options in

1	Image Size Ratio and Zoom options	6	Main image
2	Preview adjustments button	7	Loupe view
3	Selection mode button	8	Area viewed in loupe
4	Refresh Loupe Only (refreshes loupe after adjustments are made)	9	Preset thumbnails strip
		10	Process HDR file button
5	Histogram	11	HDR adjustment options

the Adjustments palette are contextual and will alter depending on whether you choose Tone Mapping or Exposure Fusion as your HDR blend type.

Loading your images

Once you've launched Photomatix you need to select the photographs that you want to convert into an HDR image.

1) Start be selecting *File>Load Bracketed Photos* or clicking *Load Bracketed Photos* button in the Workflow Shortcuts window.

2) When the Select Bracketed Photos dialog opens, click *Browse* to navigate to your image files.

3) Using the file browser, select all the images you want to merge and click *Load*. When you return to the Workflow Shortcuts window click *OK* to continue.

Workflow shortcuts

Initially used to load your bracketed images, Workflow Shortcuts has other useful options.

Select bracketed photos

In addition to browsing your hard drive for your images, you can also "drag and drop" your photos into the white box in the center of the dialog box.

Select bracketed photos.

Either navigate to your photos via the "Browse..." button or drag-and-drop image files from the Finder.

_MG_3943.dng
_MG_3944.dng
_MG_3945.dng

Browse...

Remove

☑ Show intermediary 32-bit HDR image

Cancel OK

Note

*Selecting **Show intermediary 32-bit HDR image** from the Select Bracketed Photos window allows you to save the pre-processed 32-bit image in an HDR file format such as Radiance (.HDR) or OpenEXR (.EXR). Saving your image in these formats allows you to apply other tone mapping settings at a later date, without needing to preprocess the original images again. It also means that you can tone map the image using different software.*

Single images

Ideally, you should use a sequence of bracketed images to create your final HDR image. However, it is possible to create an HDR image using a single image that has been converted and saved as a sequence of different exposures. This is often necessary if your subject is moving and it would be impossible to create a bracketed sequence of shots in-camera.

For maximum quality you need to start with a RAW file and "bracket" the exposure in your RAW conversion software, adjusting the exposure level and saving each variation with a different filename to create a sequence of 16-bit TIFF files.

The dynamic range of the RAW file will determine how much you can alter the exposure by, but you should be able to manage at least ±2 stops before the highlight and shadow detail is compromised. As with bracketing your images in-camera, using three files is a good starting point for the creation of an HDR image. One of the images should be without any exposure alteration applied, one with the exposure set to retain maximum highlight detail, and the final one with the exposure set to hold maximum shadow detail.

Once you've loaded the images into Photomatix, the exposure information dialog box will show thumbnails of the images you've just selected. You need to specify the difference in EV (stops) between the files, which you can do by selecting the required value from the pop-up menu or by double-clicking on *Exposure Value* to the right of the image thumbnail and typing in the correct value. Click *OK* to continue.

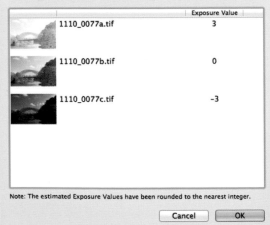

1110_0077a_b_c

Exposure information is missing, or one or more images have the same exposure settings.

Please check the estimated Exposure Values (E.V.) on the right column. If they are incorrect, either:

Specify the E.V. spacing: [3 ⬍]
OR
Change the Exposure Values manually

	Exposure Value
1110_0077a.tif	3
1110_0077b.tif	0
1110_0077c.tif	-3

Note: The estimated Exposure Values have been rounded to the nearest integer.

[Cancel] [OK]

Note
To maximize the dynamic range of your image at the capture stage it is a good idea to "expose to the right," as discussed previously.

EXPOSURE INFORMATION
Using an exposure adjustment value that is greater than ±2EV increases the risk of blown highlights and heightens noise in shadow areas.

Preprocessing

Once your images have been loaded into Photomatix you will be presented with the Preprocessing Options dialog. There are a number of choices on the screen and it's worth taking the time to work carefully through them to increase the quality of your final HDR image.

Align source images

Even if you've used a tripod to shoot your bracketed images there is still a chance that your images may be slightly misaligned. Select this option and Photomatix will automatically attempt to align the images either *by correcting horizontal and vertical shifts* or *by matching features*. When you choose *by correcting horizontal and vertical shifts*, your images are moved up and down to match each other as required, while selecting *by matching features* will scale, rotate, or shift the images as required. Perspective correction can also be applied if necessary. Given the added complexity, *by matching features* takes longer to preprocess your images, but will generally produce better results, especially if you shot your bracketed image sequence handheld.

Moving the *Maximum shift* slider sets the amount of misalignment Photomatix will attempt to correct. The greater the value, the more time it will take to preprocess your images, but the more accurate the alignment will be. If you're confident there is little misalignment in your images, leave *Maximum shift* set at its default value of 12%, or lower.

Finally, you can ask Photomatix to *Crop aligned images,* which will remove any unwanted borders that are created by the alignment process. This option is checked by default, but uncheck it if you want to keep the pixel dimensions in your HDR image the same as your source images.

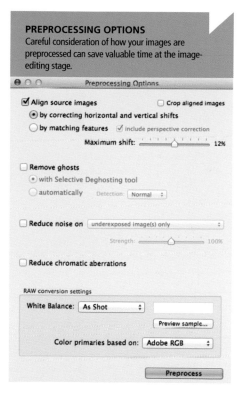

PREPROCESSING OPTIONS
Careful consideration of how your images are preprocessed can save valuable time at the image-editing stage.

Note
*If you have used a single RAW file to create an exposure sequence you do not need to use **Align source images**.*

Remove ghosts

One of the big problems with merging bracketed images occurs when there is movement in the scene between the shots. When you create your HDR image this is seen as "ghosting." Photomatix will attempt to correct this error either *automatically* or by allowing you to use the more comprehensive *Selective Deghosting tool*, using the image in your sequence that has the best exposure as the default for deghosting.

1) To use *Selective Deghosting*, check the option if it is not already set. When you click on the *Preprocess* button you will be shown the *Selective Deghosting* dialog before your images are merged.

2) In the *Selective Deghosting* window draw around the area of your image affected by ghosting. Do this by holding down the left mouse button as you move your mouse. You can complete the shape either automatically (by releasing the mouse button), or by returning to your starting point and then releasing the mouse button.

3) Once you've created your selection shape, right-click within the shape's boundary and select *Mark selection as ghosted area* from the pop-up menu. The boundary of your selection will change from a broken line to a solid line to show that the deghosting area is set.

4) Click on *Preview Deghosting* to view the results of your selection.

5) Repeat the process to add more areas that require deghosting as necessary.

6) Click *OK* to continue.

Notes

You can remove a selection by right-clicking on it and selecting **Remove selection.**

If you want to change the default exposure for a selection, right-click on the selection, highlight **Set another photo for selection**, *and choose an alternative exposure.*

Checking **Quick selection mode** *allows you to draw a selection area, skipping step 3 above.*

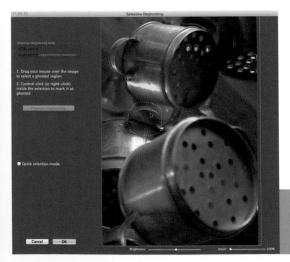

SELECTIVE DEGHOSTING
With care it's possible to reduce any ghosting in your images to a minimum.

Reduce noise

Noise can be an issue if your images are underexposed, or if you used a high ISO setting, but Photomatix can reduce image noise during the preprocessing stage. Check this option particularly if you are using RAW files, as they will have had no noise reduction applied in-camera. The *Strength* slider allows you to set how much noise is reduced; the greater the value, the greater the reduction. However, applying too much noise reduction will also reduce fine detail in your images, so it is advisable to only increase the noise reduction beyond the default value if the noise in your images is excessive.

Reduce chromatic aberrations

Visible light is a spectrum of wavelengths of electromagnetic radiation that our eyes (and cameras) can see and interpret. The longest wavelength in this spectrum corresponds to the color we see as red, the shortest to blue/violet. It is difficult (and expensive), to create a lens that can focus these different wavelengths at exactly the same point, and a lens that cannot do this is said to suffer from chromatic aberration (or CA for short). CA is seen as color fringing around the boundaries of light and dark areas of an image and is usually either green-red or yellow-blue in color. Photomatix can correct for CA automatically during the preprocessing stage: select *Reduce chromatic aberrations*.

> ## Note
>
> *There are two types of chromatic aberration—axial and transverse. Axial is seen across the whole of the image when the lens is set to maximum aperture, but is reduced as a lens is stopped down.*
>
> *Transverse CA is mainly seen in the corners of images and is visible at all apertures. Photomatix corrects for transverse CA.*

CHROMATIC ABERRATION
Green-red transverse CA is readily visible in this image, but it is easily corrected with Photomatix.

RAW conversion settings

If you're using RAW files you are offered the option of adjusting the white balance before the preprocessing stage. The default option is *As Shot*, with the information read from the camera data stored in the RAW file. If you're confident that the white balance is set correctly you can leave this option as it is, otherwise use the pop-up menu to select a suitable white balance preset or type a specific Kelvin value into the box to the right of the pop-up menu. You can preview the white balance setting you've selected for your source image by clicking *Preview sample...*

You can also set the color space that your HDR image will be tagged with. There are three choices on the *Color primaries based on...* pop-up menu: sRGB, Adobe RGB, and ProPhoto RGB. Of the three, sRGB has the smallest color range and is only really suitable for images destined for web use. Adobe RGB

is the default option and is used by Adobe Photoshop and most professional image-editing applications. Adobe RGB has a wider color range than sRGB, and is a better choice if you intend to print your images. ProPhoto RGB is a relatively new color space with an even wider color range than Adobe RGB. However, the drawback with using ProPhoto RGB is that you will need to convert your images to sRGB or Adobe RGB if you want to use them outside your own computer set up, such as when sending your images to a lab for printing.

Note

To maintain image quality you will need to set any other image-editing software to use the same color space you select in Photomatix.

DUSK *(Opposite)*
When shooting floodlit buildings at dusk I often set the camera's white balance to Daylight. I find this gives me the best compromise between the coolness of the Incandescent setting and the warmth of Cloudy.

Canon EOS 1Ds MkII with 100mm lens, three blended images at f/11, ISO 100

WHITE BALANCE
Setting the color temperature in Photomatix Pro.

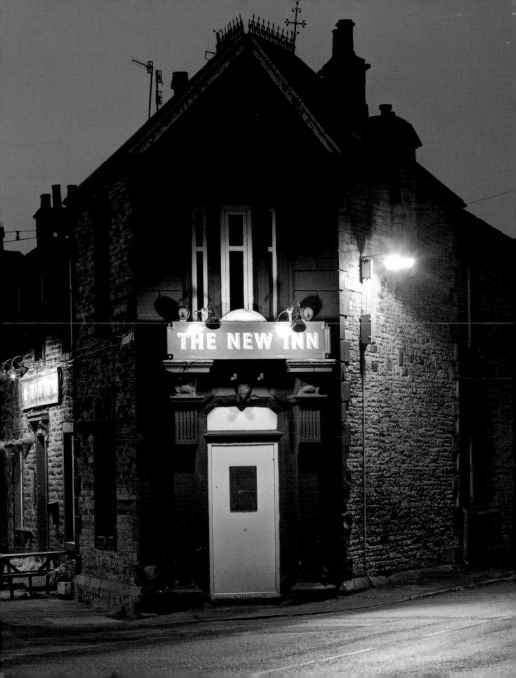

Image adjustment

Once you've passed the preprocessing stage, you will be able to make the adjustments necessary to refine the appearance of your image. There are two ways to do this—Tone Mapping and Exposure Fusion—and the options on the HDR adjustments panel will change depending on the method you choose.

To choose the processing method, select the required option from the adjustment panel.

> 1 There are further options available for Tone Mapping and Exposure Fusion that are chosen from the Method pop-up menu 2 .

Tone Mapping: Details Enhancer— general adjustments

The Details Enhancer offers five general adjustment controls.

> 3 **Strength** adjusts how contrast and detail are altered in the HDR image. The higher the Strength value, the greater the contrast and the more defined the detail will look. However, setting the Strength too high can increase the visibility of noise in the image.

> 4 **Color Saturation** alters the vibrancy of the colors in your image, with a value of 0 creating a black-and-white image. However, this isn't necessarily the best method for creating a

black-and-white image as it simply desaturates the picture, rather than allowing you to adjust the various colors as they are converted to shades of gray.

5 **Luminosity** controls how the tonal range of your image is compressed globally. The higher the value, the more shadow detail is revealed and the brighter the image will be. A lower value will produce a more natural-looking image.

6 **Detail Contrast** allows you to adjust how sharp your image is. Moving the slider to the right increases micro-contrast (the contrast at a pixel level), which increases the apparent detail in your image.

7 The **Lighting Adjustments** slider is visible when *Lighting Effects* is left unchecked, and it controls how the image is "lit." The higher the value, the more natural the HDR image will look when processed. Lower values tend to produce a more "painterly" result.

When *Lighting Effects* is checked, five option buttons replace the *Lighting Adjustments* slider. The *Natural* buttons light the image more naturally and equate to a high value on the *Lighting Adjustments* slider, while the *Surreal* buttons produce results similar to setting a low *Lighting Adjustments* value. *Medium* is self-explanatory, falling between the two.

Tone Mapping: Details Enhancer— More Options

In addition to the general adjustments, you can call up more options for the Details Enhancer:

8 **Smooth Highlights** reduces the amount of contrast in the highlight regions of your image. A higher value increases contrast and can cause highlights to look more burnt out. Lower values can make highlights look overly gray and flat.

9 **White Point** and **Black Point** control the
10 clipping points of the highlights and shadow areas of your HDR image. Moving the sliders to the right increases contrast, making it more likely that clipping will occur. Viewing the image Histogram (*View>8-bit Histogram*) will give you an indication whether this will be the case or not.

11 **Gamma** adjusts the midtones in your image: Increasing the *Gamma* value lightens the midtones, and decreasing it darkens them.

12 **Temperature** allows you to make adjustments to the white balance of your image, using the original white balance of the source images as a reference point. A higher *Temperature* value increases the "warmth" of your image, while a lower value will make the image "cooler."

Tone Mapping: Details Enhancer— Advanced Options

If you want maximum control over the appearance of your HDR images, Photomatix's Advanced Options will allow you to fine tune your results.

13 **Micro-smoothing** evens out local detail enhancements. A higher value reduces the effects of noise in your image, making it appear more natural, but a high *Micro-smoothing* value will also increase the risk of highlights burning out and will make your image look "flatter" overall.

14 **Saturation Highlights** and **Saturation**
15 **Shadows** adjust the color-intensity of the lighter and darker tones in your image respectively. Dragging the slider to the left decreases the saturation, dragging it to the right increases it.

16 **Shadows Smoothness** adjusts the detail contrast within the shadow areas of your image. Noise in shadows can be a problem, and increasing Shadow Smoothness is one way to combat it.

17 **Shadows Clipping** is another tool that can be used to combat noise in the dark areas of your images. It does this by setting the point at which your shadows turn to black. By darkening the shadows, noise is much reduced, but so is any important detail.

18 **360° image** makes sure that the left and right edges of your images match when you're blending a 360° panoramic image. Leave it unchecked if you are producing "standard," non-360° HDR images.

Note
*If you create a set of adjustments that you'd like to apply to other images you can save the settings as a **Preset** by clicking on the Preset pop-up menu at the bottom of the Adjustments panel and selecting **Save Settings**. Select **Load Settings** from the Preset menu to apply the settings to other images.*

DIFFERENT APPROACHES *(Opposite)*
The same image was converted using Tone Mapping (top) and Fusion (bottom). Tone Mapping has produced a distinct HDR look, while the Fusion result appears more natural. The option you choose for your own images is largely a matter of taste.

Canon EOS 7D with 17–40mm lens (at 17mm), two blended images at f/14, ISO 100

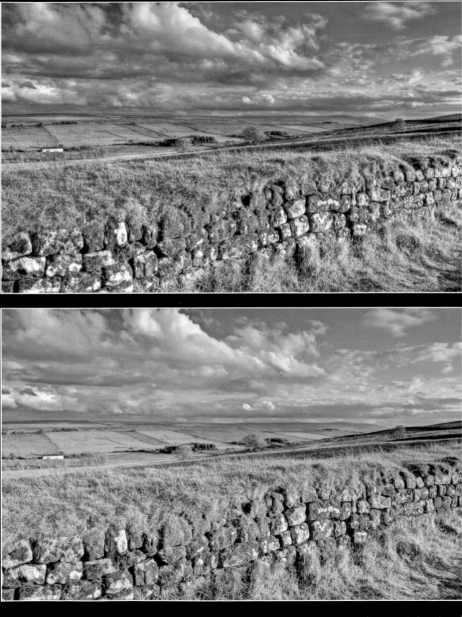

Tone Mapping: Tone Compressor

When Tone Mapping is set to Tone Compressor (rather than Details Enhancer) there are fewer options available. This makes Tone Compressor a far simpler way of producing HDR images, but you will not have the fine control offered by Details Enhancer.

1 **Brightness** adjusts the lightness of your image. Dragging the slider to the left decreases the overall image brightness, dragging it to the right increases it.

2 **Tonal Range Compression** controls the number of tones in the image between black and white. Moving the slider to the right expands the range of tones, and moving it to the left reduces the tonal range of the image.

3 **Contrast Adaptation** alters how much the image is influenced by the average brightness in relation to the intensity of the processed pixel. The further the slider is moved to the right, the less natural colors start to look. Moving the slider to the left creates a more natural palette.

4 **White Point** and **Black Point** control the
5 clipping points of the highlight and shadow areas respectively of your HDR image. Moving the sliders to the right increases contrast and increases the likelihood that clipping will occur.

6 **Color Temperature** allows you to make adjustments to the white balance of your image, using the original white balance of the source images as a reference point. A higher temperature value increases the "warmth" of your image, while a lower value will make your image "cooler."

7 **Color Saturation** alters the vibrancy of colors in your image. A value of 0 will create a black-and-white image, but this is not the best way to convert an HDR image to monochrome.

Exposure Fusion: Adjust

If you want your HDR images to appear more natural, then Exposure Fusion is the option to choose, rather than Tone Mapping. As the name suggests, it works by blending images of varying exposures together, choosing pixels from each of the source images that will give the best exposure overall. For this reason, Exposure Fusion is not available when you are working with one source image.

1 **Accentuation** controls the strength of the local contrast adjustments.

2 **Blending Point** allows you to determine which of the source images will have most influence over the final HDR fusion. Moving the slider to the right shifts the blending toward overexposed images, brightening the fused image, while moving the slider to the left shifts the blending toward the underexposed images.

3 **Shadows** alters the brightness of the shadow areas, without affecting the highlights.

4 **Sharpness** adjusts the apparent sharpness of detail in the image. However, too high a value will also increase noise and potentially create halos around elements in your image.

5 **Color Saturation** alters the vibrancy of the colors in your image.

6 **White Clip** and **Black Clip** control the clipping
7 points of the highlight and shadow areas of your HDR image respectively. Moving the sliders to the right will increase contrast, but it also increases the likelihood that clipping will occur.

8 **Midtone** adjusts the appearance of the midtone areas in an image. Moving the slider to the right brightens the image overall, but reduces contrast, while moving the slider to the left has the opposite effect.

9 **360° image** makes sure that the left and right edges of your images match if you are blending a 360° panoramic image.

Exposure Fusion: Intensive

Exposure Fusion's Intensive option offers only three controls.

1 **Strength** adjusts how contrast and detail are altered in the HDR image. The higher the Strength value the greater the contrast and the more defined detail will look. However, overuse of Strength can increase the visibility of noise in the image.

2 **Color Saturation** alters the vibrancy of colors in your image, with a value of 0 desaturating the image entirely.

3 **Radius** sets the area used to control the bias of the source image. The higher the value, the fewer halos you will see around elements in your image, but the time taken to process your image will increase.

Exposure Fusion: Two images

This option uses two images from your exposure sequence to create the final "fused" image, although you can choose which two exposures you want to use.

Note

*There are no options available for either **Exposure Fusion: Average** or **Exposure Fusion: Auto**—Photomatix chooses the settings for each.*

COLOR PALETTE *(Opposite)*
I felt this image suited a more somber feel, so I reduced the color saturation and chose a cooler color temperature than had been set when I shot the RAW file.

Canon EOS 5D with 28mm lens, 1/5 sec. at f/16, ISO 100

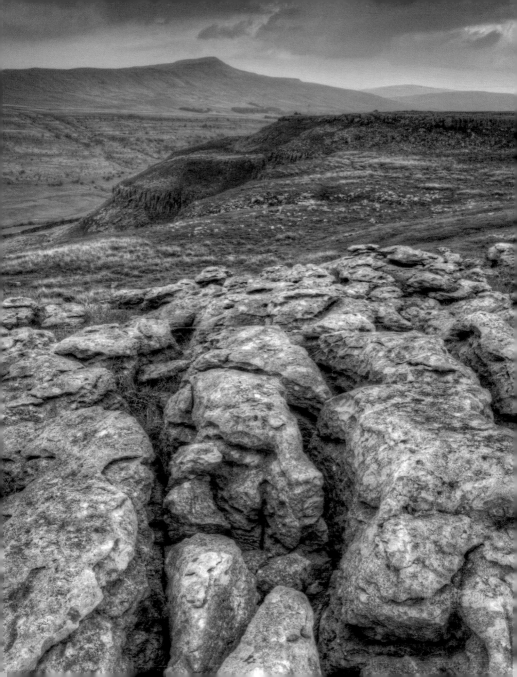

Exposure Fusion: Intensive

Photomatix Pro has a series of built-in image presets that will allow you to quickly set a particular "look" for your images. When you click on a particular preset the Process, Method, and Option sliders all change on the adjustment panel to reflect the choice you've made. You can refine the look of your image further by altering the available sliders.

1 **Enhancer** Selects default settings for Detail Enhancer.

2 **Compressor:** Selects default settings for Tone Compressor.

3 **Fusion:** Selects default settings for Fusion Adjust.

4 **Enhancer—Painterly:** Sets Process to Tone Mapping and Method to Details Enhancer. Sliders are set so that the image is less naturalistic and more like a painting.

5 **Enhancer—Grunge:** Sets Process to Tone Mapping and Method to Details Enhancer. Sliders are set so that colors are highly saturated and the resulting image appears unnatural.

6 **Enhancer—Smooth:** Reduces contrast enhancement in the highlights of the image.

7 **Enhancer—B&W:** Color Saturation is set to 0 and the image converted to monochrome.

8 **Compression—Deep:** Produces a darker image with slightly more pronounced colors.

9 **Fusion—Adjusted:** Selects default Exposure Fusion with adjusted settings.

FLOWERS *(Opposite)*
The same output using different presets: (top left) Fusion, (top right) Enhancer—Grunge, (bottom left) Enhancer—B&W, and (bottom right) Enhancer—Painterly.

Canon EOS 7D with 50mm lens, 1/500 sec. at f/1.4, ISO 100

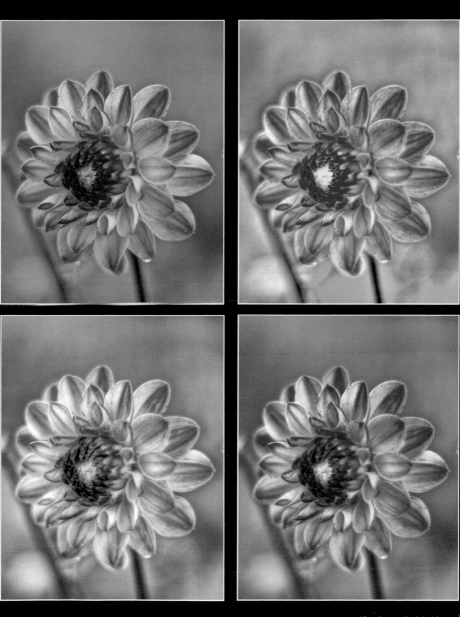

Subtle

Although it's tempting to push every slider in Photomatix to its maximum setting, the results can veer toward the gruesome. This image was a simple Exposure Fusion blend of three images. My intention was to use Photomatix to create an image that was reasonably faithful to how I remembered the scene.

Camera: Canon EOS
1Ds MkII
Lens: 17–40mm lens (at 40mm)
Exposure: Three blended
images at f/13
ISO: 100

Movement

Unless the air is very still, foliage will invariably move during the exposure bracketing process. One way to reduce this possibility is to use the fastest sequence of exposures you can. However, you may find this difficult to achieve if you want to use a small aperture and a light-sapping filter such as a polarizer. However, the deghosting facility in Photomatix can come to the rescue, and even the automatic option does an excellent job of removing movement blemishes.

Camera: Canon EOS 1Ds MkII
Lens: 17–40mm lens (at 17mm)
Exposure: Three blended images at f/16
ISO: 100

Introduction

No matter how carefully you create your HDR image there will always be a few tweaks that can be made afterward. This chapter looks at some of the ways that you can adjust your HDR images, as well as a few common problems and their solutions.

HDR can look good straight after processing, but generally there will still be some work to be done. What this work is will depend on the settings you've used to create the HDR image and, to a certain extent, your own personal tastes.

It's probably fair to say that Adobe Photoshop is the image-editing program that is most associated with digital photography. In fact, the two are so closely associated that the name has now become a verb—most people will know what you mean if you say an image has been "Photoshopped." For that reason, this chapter covers some of the basic adjustment tools in

Photoshop, although many of the tools will also be found in other image-editing programs.

It does not take long to develop a recognizable personal photographic style. Rather ironically, this is often achieved by looking at the work of others—not to copy slavishly, but to seek inspiration that can be fed back into your own work. This inspiration can also take a negative form, in that you may not like everything you see! This is also useful, as it will help guide you away from time-consuming photographic dead-ends.

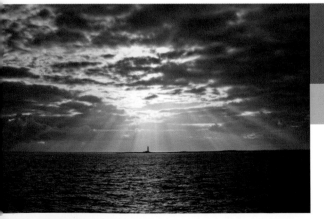

BLACK AND WHITE
My tastes have changed over the years. Currently I'm very interested in black-and-white imagery, particularly when dramatic light is breaking across a landscape.

Canon EOS 5D with 50mm lens, 1/2000 sec. at f/10, ISO 400

STAINED GLASS *(Opposite)*
I felt that the subject of this image suited a more muted approach.

Canon EOS 1Ds MkII with 70–200mm lens (at 200mm), three blended images at f/11, ISO 100

Tonal adjustments

The most basic adjustment you can make to your HDR images is improving the tonal range. This can be as simple as increasing the overall contrast to add more "bite" to an image, or as subtle as altering the tonal values of very specific areas in a picture.

Brightness/Contrast

The very first version of Photoshop featured the Brightness/Contrast tool. Although there are more sophisticated ways of adjusting image brightness or contrast in Photoshop, it is still worth using if you are looking for a very quick and straightforward way to make global tonal changes to your image.

1) Open your HDR image and select *Image>Adjustments>Brightness/Contrast*. If you are using Photoshop CS3 or above, leave *Use Legacy* unchecked. This is because the "Legacy" option uses an older, less esthetically pleasing way of adjusting brightness or contrast.

2) Moving the *Brightness* slider to the right expands the highlight range in an image, while moving the slider to the left expands the shadow range. It generally doesn't take much adjustment for the highlights or shadows to become burnt out or blocked up respectively, so use this slider with caution.

3) The *Contrast* slider compresses or expands the tonal range in an image. Moving the slider to the right, which squeezes the range of tones, increases contrast. Moving the

slider to the left decreases contrast, making images appear "flatter."

4) Once you're happy with the results of your adjustments click *OK* to apply them to your image.

Brightness/Contrast		
Brightness:	0	OK
		Cancel
Contrast:	0	☑ Preview
		☐ Use Legacy

Note

*Switching **Preview** on or off lets you see your image before and after adjustment without committing yourself by pressing OK. This applies to all the adjustments detailed over the next few pages, with the exception of the Dodge/Burn/Sponge tool.*

Hue/Saturation

With the Edit pop-up menu set to *Master*, Hue/Saturation allows you to make very quick and simple global adjustments to the colors in your image. However, by choosing a specific color set from the Edit menu it is possible to affect only a very narrow range of colors, allowing you to target color problems in your images with greater precision.

1) Open your HDR image and select *Image>Adjustments>Hue/Saturation* from the main menu.

2) Dragging the *Hue* slider cycles the RGB values of the colors in your image. At the bottom of the dialog box are two strips of color. The top strip represents the full range of potential colors in an image, while the bottom strip shows how those colors will be shifted by a *Hue* adjustment.

3) Dragging the *Saturation* slider to the left decreases the amount of saturation in your image, while dragging the slider to the right increases saturation.

4) *Lightness* adds more black to your image when the slider is dragged left, or adds more white when it is dragged to the right.

5) If you want to tint an image a particular color, select *Colorize* and use the sliders to fine tune the tint.

6) Once you're happy with your adjustments click *OK* to apply them to your picture.

Levels

Using Brightness/Contrast can be frustrating as it's an "all or nothing" tool that doesn't offer any way to fine tune your results. While Levels is initially a more daunting method for adjusting the tonal range of your image, it allows you to make very sophisticated alterations.

1) Open your HDR image and choose *Image>Adjustments>Levels* from the main menu to open the Levels dialog.

2) At the center of the Levels window is a histogram showing the distribution of tones in your image, and below this are three small triangles. By default the solid black triangle is on the far left of the histogram and shows you where the black point of your image is. The solid white triangle on the far right shows the white point. Finally, the gray triangle shows you where the midtones of your image are.

Unsurprisingly, this is initially at the center of the histogram.

3) You can alter the black, midtone, and white points of your image by moving the relevant triangles. Moving the white triangle to the left increases the number of pixels in your image that are white, and moving the black triangle to the right increases the number that are black. If you move the gray (midtone) triangle to the right your image will darken, move it left and the image will lighten.

4) You can also quickly set the black, midtone, and white points in your image by clicking the relevant color pickers below the *Options* button. With a color picker selected, click anywhere in the image and, depending on the color picker you selected, the color value of the pixel you clicked on will become the new black, midtone, or white point.

5) *Output Levels* changes the RGB value of the darkest and lightest tones in your photo. Move the black output level right and the darkest tone lightens, move the white output level left and the lightest tone darkens.

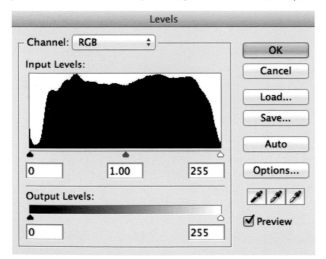

6) If you've made a particularly pleasing adjustment and you want to apply it to other images, you can save and load the adjustment by clicking on *Save* and *Load* respectively.

7) Once you're happy with the results of your Levels adjustment click *OK* to apply it to your image.

Shadows/Highlights

As long as the highlights or shadows in an image aren't clipped, there is generally still scope to adjust them to improve an image (subject to noise, particularly in shadow areas). The Shadow/Highlight tool in Photoshop is a simple way to do just that. In fact, it is possible to create a pseudo-HDR effect by pushing the corrections to their limits. Shadow/Highlight does not simply darken or lighten your images: it lightens or darkens a pixel in the image depending on the luminance values of its surrounding pixels. These surrounding pixels are known as the "local neighborhood."

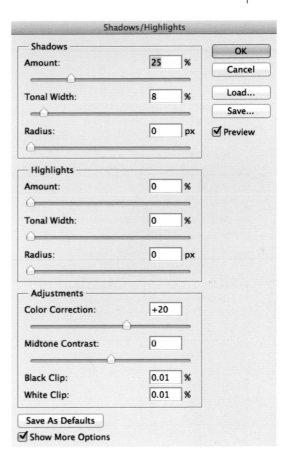

1) Open your HDR image and select *Image>Adjustments>Shadows/Highlights*.

2) For maximum control of the adjustments check *Show More Options*.

3) To add more "light" into the shadow areas, or to darken the Highlights, drag the relevant *Amount* slider: the greater the % value, the greater the adjustment. The *Tonal Width* slider controls the range of tones affected by the *Amount* slider. If a low value is used, only the very darkest tones are affected. The higher the value, the more midtones are affected. *Radius* controls the number of pixels that are regarded as being in the local neighborhood to individual pixels.

4) If the adjustments above alter the colors in your image in an unexpected way, you can use *Color Correction* to refine the color. *Midtone Contrast* adjusts the contrast of the midtones in your image; dragging the

slider to the right increases contrast, dragging it left reduces contrast. *Black Clip* and *White Clip* specify how close the shadows and highlights in your image will get to 0 or 255 respectively after your adjustments. The greater the value used, the more contrast will be added to your image.

5) Once you're happy with your adjustments click *OK*.

Curves

The Curves tool is by far the most sophisticated of the tonal adjustment tools in Photoshop, and also one of the most complex. However, once the basic concept has been grasped it's a tool that will prove indispensable.

On the Curves tool palette are two grayscale bars, one running horizontally below the Curves box and the other running vertically to the left. The horizontal bar shows the Input levels and represents the range of tones in your image from black on the left to white on the right. The vertical bar is the Output levels and represents the tones after any adjustments have been made.

A line runs diagonally across the Curves box from top right to bottom left, and this is the curve itself. You can add up to fourteen points on the curve, allowing you to make quite complex adjustments to specific areas of the tonal range in your image.

1) To call up the Curves dialog, open your image and select *Image> Adjustments> Curves*.

2) If you click halfway along the diagonal line a point will be drawn—this is known as a "neutral curve." Now imagine a straight line running down to the Input bar. It should correspond to a midtone. Look back at the point and then across to the Output bar. It should correspond to the same midtone. This means that the Input and the Output are the same (2).

3) Now left-click on the point you created and drag it upward a little way (3a). The Input will remain the same, but the point will be aligned with a lighter Output tone. What you have just done is adjust the midtones to make them lighter. If you had moved the point on the curve

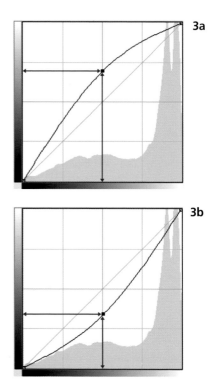

3a

3b

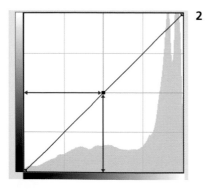

2

downward (3b), the midtones would have been darkened instead.

4) As with Levels, moving either of the triangles below the Input bar moves the black or white point in your image. When you move the triangles, the end points of the curve change to reflect the new white or black point.

5) You can also set the black, midtone, and white points in your image manually by clicking on the relevant color picker below Input, and then clicking on the image. This works in the same way as Levels.

6) In addition to manipulating the curve, you can also draw your own freehand curve. Click on the "pencil" icon just below the Channel pop-up menu and draw in the Curves box by holding down the left mouse button. Try to draw smoothly and without a break in the line.

7) If you want to adjust one of the color channels separately, click on the Channels pop-up menu and select either *Red*, *Green*, or *Blue*. This is useful if you want to increase or remove a particular color bias in your image. Pulling the curve downward reduces a color bias, while pulling it upward increases it.

8) If you're happy with an adjustment, it can be saved and loaded again for use on other images by clicking on *Save* and *Load* respectively.

9) Once you're happy with your Curves adjustment click *OK* to apply it to your image.

CONTRAST
An "S" shaped curve (right) will add contrast to an image, as seen in the images below.

Black and White

Simply draining the color from an image to create a black-and-white picture often results in disappointment. This is because midtone colors such as red, green, and blue are treated equally and, when they are converted to black and white, they all end up as mid-gray and no longer look radically different to each other.

Controlling how certain colors are converted into shades of gray will result in a more satisfying image. Before digital imaging, this was achieved through the use of colored filters on the camera. The filter would allow wavelengths of light that were similar in color to itself to pass through, and either reduce or block the wavelengths that were dissimilar. For example, if a red filter is used for a black-and-white shot that includes the sky, the blue of the sky will darken considerably—certainly more than the mid-gray tone you'd see without the filter. Conversely, using a red filter when shooting a picture of a red apple will cause the apple to appear lighter in the resulting black-and-white image.

Most HDR software will allow you to create black-and-white images, but for greater control the Black and White conversion tool in

Canon EOS 1Ds MkII with 24mm lens, two blended images at f/10, ISO 100

DRAMA
Black and white is ideal for recording dramatic landscapes. For this image I made two exposures—one for the sky, and one for the foreground. I then created the HDR image using Photomatix Pro, importing the color image into Photoshop for the black-and-white conversion.

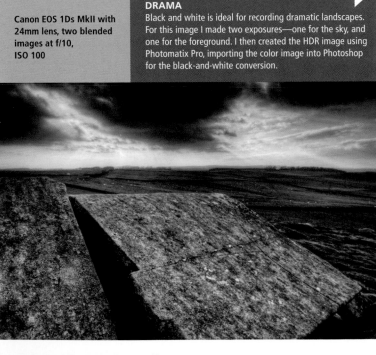

Photoshop should be used. This tool allows you to mimic the effect of colored filters to fine tune your black-and-white conversion.

1) Start by choosing *Image>Adjustments>Black and White* from the main menu to open the Black and White dialog window. If *Preview* is checked your image will be displayed in black and white using the default settings. Click *Auto* to allow Photoshop to determine how the color sliders should be set.

2) The *Preset* pop-up menu has a range of default settings that replicate the effects of using different colored filters as well as some more esoteric options such as *Infrared* and *Maximum Black*. Selecting one of these presets will set the sliders automatically to the relevant settings for that particular effect.

3) If you'd rather create your own effect you can adjust how the colors in your image are converted to black and white by moving the relevant sliders. The greater the percentage of a color, the lighter the gray tone conversion of it will be. Conversely, the smaller the percentage that is set, the darker the gray tone will be.

4) You can save and load your black-and-white settings for future use by clicking on the icon to the right of the Preset pop-up menu. Select *Save* and then give your custom preset a relevant file name. By default, custom presets are saved in Photoshop's Black and White preset folder. Once saved, the custom preset can be found in the Preset pop-up menu.

5) One further refinement you can make to your black-and-white images is tinting them. Select *Tint* at the bottom of the dialog box and use the *Hue* slider to choose your desired color tint and the *Saturation* slider to determine its intensity.

6) When you're satisfied with your Black and White adjustments click *OK*.

Dodge, Burn, and Sponge tools

The name of the Dodge and Burn tools might be slightly puzzling if you've never been in a black-and-white darkroom. They both come from the technique of selectively altering areas of tone in a print as it's being exposed under an enlarger. When you create a darkroom print, the longer it is exposed to light, the darker it will be when it's developed. Dodging is the act of holding back light, using a mask to stop an area of the print from getting darker. Burning is the opposite, allowing an area of the print to be exposed further to make it darker. The Sponge tool has no equivalent in the darkroom, but allows you to selectively decrease or increase saturation in your image.

All three of these tools are found on the tools palette, but only one is shown at a time: right-click on the icon of whichever is currently shown and then select one of the others from the sub-menu. Once you've selected your tool, you need to set the size (in pixels) and hardness of its "brush" by using the pop-up menu on the Option bar. *Size* can also be adjusted by pressing the "[" key to shrink the tool and the "]" key to enlarge it.

BURN TOOL
Areas of an image can be quickly darkened using Photoshop's Burn tool.

The tones that the Dodge and Burn tools affect are set in the Range menu. Select *Shadows* and the tool will be biased toward affecting the darker tones in your photo, *Midtones* the middle tones, and *Highlights* the brightest tones. Exposure alters how quickly the Dodge and Burn tool affects the tones you are altering, with a higher value building up the alteration more quickly than a lower value.

If you have the Sponge tool selected you can choose whether it *Saturates* or *Desaturates* from the pop-up menu. *Flow* selects how quickly or otherwise the Sponge tool affects your image.

Layers

One of the problems when working with an image in Photoshop is that any changes you make are permanent. You can, of course, undo or step back through the alteration history, but this has limitations—you may have to undo alterations you are happy with to undo those you are not so pleased about, and you cannot undo anything once you have saved, closed, and reloaded the image.

Layers are one solution to this problem. A layer can be thought of as a sheet of glass laid over your image, so any adjustment you make on a layer will not permanently affect the image underneath. It doesn't stop there. You can copy all or part of your image to a new layer, allowing you to work on the copy rather than the original. If you want to start over, it's simply a matter of deleting the layer and creating a new one.

Photoshop lets you add numerous layers to an image, and they can be seen stacked one on top of each other in the Layers palette (select *Windows>Layers* if the palette isn't shown). The highest layer in the stack is shown at the top of the Layers palette, while the lowest layer (which by default will be called Background) is at the bottom. The order of the layers can be changed by left-clicking and dragging a layer up or down the stack.

Changing the *Opacity* value alters the transparency of a layer: at 100% the layer is fully visible, at 0% it is completely transparent. You can also change how the layer interacts with those below by selecting different *Blending modes* from the pop-up menu. The *Blending mode* determines how pixels interact and are mixed between the various layers. "Normal" is the default mode.

Turning a layer on or off temporarily is achieved by clicking on the "eye" icon to the left of the layer strip in the layers palette. You can also permanently remove a layer by dragging it to the trashcan icon at the bottom of the palette.

Note

Not all file formats allow you to save an image with the layers intact. Compatible file types include Photoshop's PSD format and TIFF files, but if you want to save your image as a JPEG file you will first have to combine, or "flatten" all the layers, or save it as a flattened copy.

Layers palette

4. Fill. Similar to Opacity in that the Layer contents will become more transparent, with the exception of applied layer styles.

5. View layer. Clicking on the eye icon will turn the selected layer on and off.

6. Layer group. Layer groups can be used to "store" layers. This can be used to keep your layers palette from looking too cluttered and to collect related layers into one "package." A group can be switched on and off like individual layers, hiding all the layers within the group.

7. Color balance adjustment layer.

8. Layer mask applied to a copy of the Background layer.

9. Color Overlay layers effects applied to a copy of the Background layer.

10. Link layers button. Layers can be temporarily linked together for moving or merging, without affecting unlinked layers.

11. Add layer style. Adds an effect to a layer such as a stroke or color overlay.

12. Add layer mask. Applies a mask to the selected layer.

13. Create new fill or adjustment layer.

14. Create new group.

15. New layer. Dragging an existing layer to the new layer option will make a copy of that layer.

16. Delete layer.

1. Blending mode. The default blending mode is Normal.

2. Options menu. Includes options for flattening and merging the layer stack.

3. Opacity. A lower opacity value will reduce the transparency of the selected layer, allowing all of the layers below to be seen more easily.

Adjustment layers

All of the tonal adjustments covered so far (with the exception of the Dodge, Burn, and Sponge tools) can also be applied to an image as an adjustment layer. An adjustment layer is added to the layer stack just like a normal layer, but it does not contain any pixel information. Instead, an adjustment layer affects the layers beneath it by applying the chosen adjustment to them.

As an example, let's say that you want to apply a Brightness/Contrast adjustment layer to your image. You would do this by clicking on the *New fill* or *Adjustment layer* button in the

Layers palette and then selecting Brightness/Contrast from the pop-up menu. The standard Brightness/Contrast dialog box will open and you would make any adjustments as described previously. Once you click *OK*, the adjustment layer is created and your Brightness/Contrast settings applied to the layers below. However, because the settings are associated with an adjustment layer, you can turn off this adjustment and the Brightness/Contrast settings will also be turned off.

Note

If you want to change an adjustment layer's setting, double-click on the icon in its layer strip.

BURN TOOL
(Below) Adjustment layer added, but temporarily turned off.
(Bottom) Adjustment layer added and turned on.

Layer masks

If you alter the opacity of a layer so that it is more or less transparent, you affect the entire layer, but adding a Layer Mask allows you to select which part of a layer is transparent and which is opaque. If you create a Layer Mask, but then decide you don't like the result, you can delete it without affecting the associated layer, or edit it to refine it further.

To add a layer mask to a layer, select the layer and click the *Add layer mask* button at the bottom of the layer palette. A white-filled box will be visible to the left of the layer image thumbnail: this box represents the layer mask. The simple rule to remember is that if the layer mask is white, the associated layer is opaque.

To make the layer mask less opaque, or even transparent, set the foreground color to black and use the Brush tool (or any other painting/drawing tool) to paint anywhere in the image. As long as the *Opacity* of the brush is set to 100% you will see the layer beneath begin to show through.

Anywhere that is black in a layer mask is completely transparent (just as anywhere that is white is completely opaque), so if you pick a mid-gray as your paint color, the layer below would be semi-visible (mid-gray is equivalent to 50% transparency). The darker the paint color, the more transparent the layer mask becomes.

Using layer masks makes it possible to create very subtle gradations between layers. They are particularly useful when used in conjunction with adjustment layers if you only want the adjustment to affect one area of an image.

LAYER MASKS
Shown left is the layer stack used to create the image on the page opposite. I've applied three adjustment layers with layers masks. The adjustment layers are not affecting the left side of the image because the layer masks are set to black. The right side of the image is being altered because the right side of the layer masks is set to white.

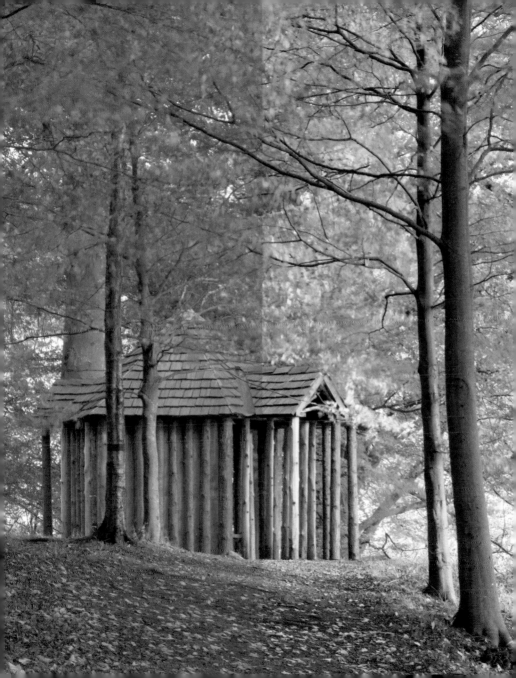

Improving contrast

HDR images can initially look very flat, and lack "sparkle." A simple way of bringing life back to an image is to adjust the contrast.

Riding the curve

Brightness/Contrast has been mentioned as a way to control contrast, but a more refined way of achieving the same thing is to use the Curves tool. One of the problems with HDR images is that often the tonal range is squashed into the midtone area, so shadows look overly bright and highlights appear dull. This is precisely the problem that occurred with the sample image shown here.

The solution in this instance was to use the Curves tool on an adjustment layer and pull in both the black and white points until the shadows and highlights looked correct. I then added too points to the Curve and created a gentle "S" shape to add contrast. After that adjustment the sky and the hills in the distance still appeared flat (a common problem in landscapes if there is haze). To fix this I created a new Curves adjustment layer, adjusted the contrast for the sky, and then painted into the layer mask so that the adjustment did not affect the foreground.

CAIRN
The initial Curves adjustment applied to the image (below), and the layer mask used on the second adjustment layer to affect only the sky.

Canon EOS 7D with 17–40mm lens (at 17mm), 1/2 sec. at f/11, ISO 100

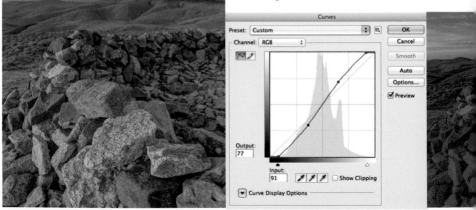

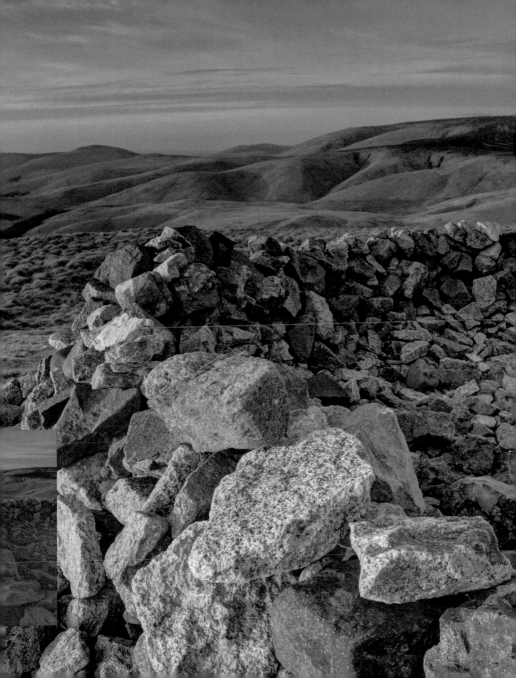

Dirty whites

Highlights in your images should be white, not a dull gray. It's often difficult to achieve this in HDR software, and trying to correct the problem often causes other issues.

Dodging the issue

Photoshop often has many different ways to achieve the same (or similar) result. The simplest method to brighten areas of an image is to use the Dodge tool. In this example image the bright sky behind the tree canopy has been turned a dull gray. Fortunately the problem is relatively localized so, using a large, soft brush and setting the Dodge tool to *Highlights*, I was able to "paint" out the gray without adversely affecting the greens of the tree canopy.

If I'd wanted to be more precise, I could have made a selection using the Magic Wand tool. This Magic Wand creates a selection based on the color of the pixel you click on when the tool is selected. In this instance, clicking somewhere in the gray portion of the sky would work. By switching off *Contiguous* in the Option bar, any similar gray pixel anywhere in the image would be selected—how similar it would need to be would be determined by the *Tolerance* value. With the dirty white areas selected I could then continue to use the Dodge tool, or another tonal adjustment tool such as Curves, to make the necessary changes to the image.

SELECTION
With a selection made using the Magic Wand it's a simple matter of using the Curves control to make the necessary tonal adjustment(s).

Canon EOS 1Ds MkII with 17–40mm lens (at 17mm), three blended images at f/11, ISO 320

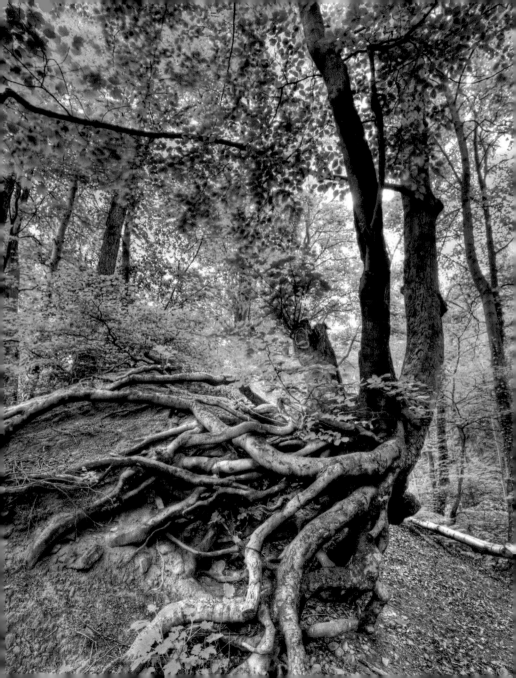

Halos

A common problem with HDR images is the appearance of bright halos around elements in the image.

Contrast first

There were several issues with this image after the HDR process was complete. The first problem, the "flatness" of the image, was easily fixed by applying a contrast-boosting "S" Curve. The second, and more serious problem was the

ugly halo around certain elements in the image, the halo around the lamp at the top left of the image being particularly noticeable. Halos in HDR images are usually formed when there are high contrast elements in an image. In this case a halo formed because the black lamp was far darker than the surrounding wall. If you're using Photomatix, a reduction in *Luminosity* can often minimize the problem.

In Photoshop, there are several ways to fix the problem after your HDR image has been processed. If the halo is relatively small, you could use the Burn tool to darken it, so that it matches

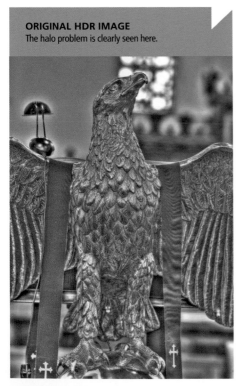

ORIGINAL HDR IMAGE
The halo problem is clearly seen here.

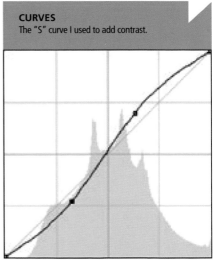

CURVES
The "S" curve I used to add contrast.

its surroundings. Setting the tool to a softer value will make the effect subtler and more easily controllable. If you burn too much you can fade the effect by going to *Edit>Fade Burn Tool* and reducing the *Opacity* setting.

Another way to reduce the effect is to use one of the source images and, using a mask, blend it over the HDR image. This is the method I used to create the image below right. The first task is to make sure that the colors between the source and the HDR image match. In this instance it was just a case of matching the white balance, but I could have refined the colors in the source image by using Hue/Saturation if necessary.

Masking

Once the source photograph was copied into a layer in the HDR image I added a layer mask set to black so that none of the source image was showing. I set the foreground color to white and, using the Airbrush tool, gently painted around the edge of the lamp to reveal the

source image and cover the halo in the HDR layer. The mask didn't need to be too precise and ultimately looked quite rough. However, it was good enough to hide the halos without any obvious alteration. Once I was satisfied with the results, I flattened the layers and saved the modified HDR image.

THE RESULT
With halos removed.

Canon EOS 1Ds MkII with 70–200mm lens (at 150mm), three blended images at f/4, ISO 100

LAYER MASK
The masking was rough, but effective.

Oversaturated color

If there is one "style" that gives HDR images a bad name, it is oversaturated pictures that are almost painful to look at.

Beyond reality

It's very tempting to make your pictures "louder" by increasing the strength of the various effects sliders, but this will not necessarily turn your images into art. Undoubtedly there are subjects that would suit a more garish approach, but they are few and far between. If you do shoot such a

subject it will also have less impact if all your previous photos have a similar color palette.

Natural subjects such as landscapes certainly rarely benefit from oversaturated colors. Take the image on the opposite page, for example—it's a lesson in all that can go wrong in the HDR process. The reds in the sunset are too "hot," and the frosty areas (which were blue in the original photos), are too cyan. They aren't the only problems of course, but the over-the-top color palette is the most obvious.

Although it would be easier to start again, there are one or two fixes that could be made to this image to rectify matters. The Hue/Saturation tool in Photoshop could be used to globally alter the saturation, although it would be best employed in altering specific parts of the color palette; the red/oranges and the blue/cyans. If you do want saturation in your image, try boosting only one color—this will have far more impact than saturating all of the colors.

GATE POST *(Opposite)*
The image on the opposite page was converted using Photomatix's Enhancer Grunge preset. However, the image on this page was converted using Photomatix's Fusion Intensive, which has resulted in a far more natural look.

Canon EOS 1Ds MkII with 17–40mm lens (at 36mm), two blended images at f/13, ISO 100

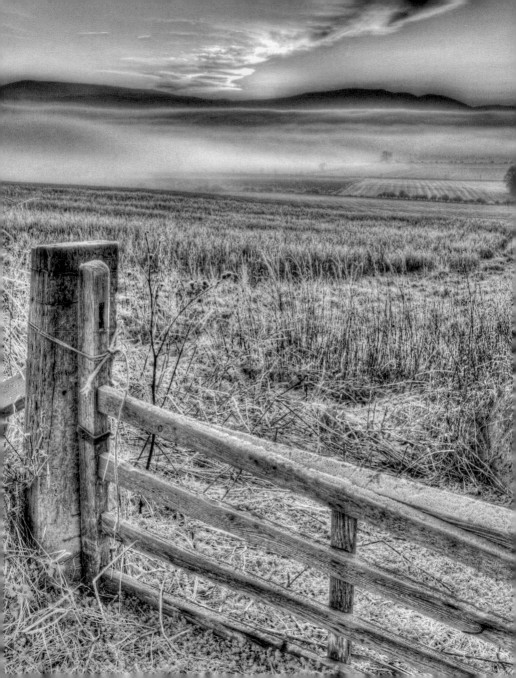

Shots with your subject engaged in an activity can make for very powerful images. This will make creating a series of bracketed shots for HDR difficult, and sometimes impossible. I couldn't stop the action for this shot, but I made sure that the exposure was set so that the maximum amount of information was retained in the shadows and highlights. I then created the HDR image from a single RAW file.

Camera: Canon EOS 5D
Lens: 50mm lens
Exposure: 1/200 sec. at f/11
ISO: 400

Gaze

It's important to get the eyes of your subject sharp as that's where we tend to look first when looking at a portrait—there's something slightly unsettling about seeing out-of-focus eyes in an image. If you have a camera with Live View, it's worth taking an extra few seconds to magnify the live image and check that your focus is precise.

Camera: Canon
EOS 5D
Lens: 70–200mm lens
(at 200mm)
Exposure: 1/160 sec. at f/4
ISO: 400

CHAPTER 7 SUBJECTS

Introduction

Your interests and life experience will help shape the photographic themes that inspire you. This chapter explores some of these themes.

Personally, I'm a landscape photographer. But I also shoot architecture. And people, animals, plants, created and natural objects, and… well, perhaps just saying that I'm a photographer would have been a whole lot easier?

Photographers do tend to be labeled as specialists of one particular genre. It's certainly true that my preference is for landscape photography, as it's the natural world that interests me the most, but I also relish the challenge of working in new fields and (hopefully) learning new skills as I do so.

Similarly, you may well have taken up photography with the intention of pursuing a particular interest, but while that is very laudable, you may also find that doing so quickly constrains what you're able to learn. The key to keeping your photography fresh is to dabble in other areas, and occasionally leave your comfort zone altogether. There's no reason that you can't mix and match genres either; with a little bit of thought you could combine landscape with portraiture, for example, or architecture with travel, or any other combination you can think of.

OUT IN THE WILDS
Even though I like to try new aspects of photography, I always feel the need to return to landscape as often as possible.

Canon EOS 5D with 24mm lens, three blended images at f/11, ISO 100

MARKETPLACE *(Opposite)*
Whatever your preferred subject matter, HDR is an invaluable technique.

Canon EOS 5D with 200mm lens, 1/400 sec. at f/3.2, ISO 400

Landscape

In many respects HDR and landscape photography is an ideal combination, as the landscape practitioner often has to deal with extremes of light and shade that HDR can overcome.

Light

When working in a studio, light can be controlled very precisely as required, but the landscape photographer does not have this luxury and must use the light that is available. However, it's a common misconception that there are "bad light" days for landscape photography. Even the soft light of an overcast day is good for certain subjects—I often prefer this type of light for shooting details or when working in woodland, for example.

The one defining quality of soft light is that contrast is reduced, so there are generally no deep shadows or bright highlights. That doesn't mean that the light is completely flat and everything evenly lit—even when the sun is hidden by cloud there will be directional light. This means that there will still be a difference in contrast between the side of an object facing the brightest part of the sky (where the hidden sun is) and the opposite side. Even in the softest light HDR can have a use in bringing out detail in these shadow areas.

FALL
Deciduous trees are a riot of color in the fall months. I prefer to spend overcast days in woodland as the softer light is more suitable for the subject.

Canon EOS 7D with 70–200mm lens (at 200mm), 1/200 sec. at f/4, ISO 400

Visible light is made up of different wavelengths, which are affected to different degrees: blue wavelengths are short and they are scattered and absorbed more then the longer red wavelengths, for example. If you are at a high altitude, the atmosphere is thinner and the more intense and blue the light will become. Ultraviolet light is also more intense at altitude, which is when a UV filter is most useful.

Sunlight passes a shorter distance through the atmosphere at midday, when it is high overhead, than it does at sunrise or sunset, when it is closer to the horizon and is therefore passing more obliquely through the atmosphere. This results in more of the blue wavelengths being absorbed at sunrise or sunset, so the light is far "warmer" than it is at midday. Contrast is also reduced at this time of day.

Weather

The weather is the biggest challenge for the landscape photographer. Weather forecasting is far more accurate than it used to be, but the further into the future a forecast is projected, the less reliable it will be. Fortunately, bad weather isn't necessarily a disaster and, as mentioned previously, overcast days are perfect for detail shots.

Changeable weather also has its attractions. By their very nature, storm clouds are dramatic,

WARMTH
Light at the end of the day is very flattering to the landscape. Not only is the light "warmer," but also side-lighting from the low sun picks out textural detail.

Canon EOS 1Ds MkII with 17–40mm lens (at 24mm), 1/2 sec. at f/16, ISO 100

and being in the right place at the right time can mean the difference between a good image and a great one. This does of course mean that there is a risk of getting wet, but preparation will see you through the worst. Oddly enough, "good" weather isn't necessarily ideal for interesting imagery. Blue sky, without cloud, is featureless and the light can be hard and unflattering. If a high-pressure system remains in place for a while, dust and smog will also start to build up, resulting in reduced visibility, particularly in the distance.

ESTHETICS
Choose an image style to suit your subject. Black and white works well with dramatic scenes.

Canon EOS 1Ds MkII with 100mm lens, 1/200 sec. at f/11, ISO 100

Looking after yourself

A landscape photographer inevitably has to venture out into the countryside and, while the outside world can be benign, conditions can change rapidly for the worse, particularly at higher altitudes. Part of the skill in being a landscape photographer is knowing how to take care of yourself, because no photograph is worth taking unnecessary risks for.

Before you set off for a photographic adventure there are important tasks you should perform first. The most important is deciding exactly where you are going to, how you are going to get there, and how long you will be away. You should then convey this information to someone trustworthy. When you return you should let that person know that everything is well and that you've returned.

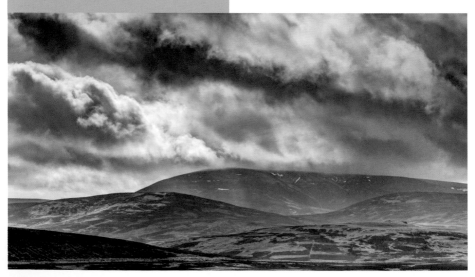

Next, make sure that you pack a compass and up-to-date map of the area you are going to. Do not rely on a GPS unit. They are excellent as a back up, but they can get damaged and the batteries depleted. A fully charged cell phone is useful too, but if you get into trouble only call the emergency services as a last resort—merely being lost is not a good reason to make that call. If you are heading into a more remote location you may find that you can no longer get a signal on your phone, so carrying a whistle is a good idea. The internationally recognized distress signal is six blasts followed by a period of silence. This should be repeated until help arrives.

You should also wear appropriate clothing for your trip. Warm and waterproof layers are essential, particularly in winter, and comfortable boots that support the ankles are highly recommended. If you're going to be out all day, take food and water with you—water is especially important to avoid dehydration. Finally, check the weather forecast for the day. If possible, use a specialist mountain or fell forecast, as they tend to be more accurate

ALTITUDE
Even the most benign of weather can quickly change as you climb higher into the hills.

Canon EOS 7D with 17–40mm lens (at 20mm), 0.6 sec. at f/14, ISO 100

Camera: Canon EOS 7D
Lens: 17–40mm lens
(at 20mm)
Exposure: Two blended
images at f/13
ISO: 100

NOISE

Sunrise and sunset are often the times when the landscape is at its most colorful, and, if you're shooting toward the sun, when contrast is extremely high. This is of course when HDR comes into its own. On this occasion I knew I'd have to blend shots together as my camera could not capture the full range of brightness in the scene, despite using a 3-stop neutral density filter over the sky. I had to work quickly as my tripod was gradually sinking into the sand; not the ideal situation for achieving the sharpest shots!

Camera: Canon EOS
1Ds MkII
Lens: 17–40mm lens
(at 24mm)
Exposure: Two blended
images at f/18
ISO: 100

DEPTH
Wide-angle lenses are commonly used by landscape
photographers because they are great at conveying a sense of
space. However, this can work against you, as it's all too easy
for a composition to look empty and uninteresting. For this image
I made sure that the foreground was filled by setting the camera
low to the ground and choosing my position carefully.

Camera: Canon EOS 7D
Lens: 17–40mm lens
(at 17mm)
Exposure: 2 sec. at f/13
ISO: 200

DUSK

Once the sun has set, the light on the landscape is far softer. However, there is often a lot of contrast to contend with still. The sky is often far brighter than the foreground, for instance, and, although the sun has set, there is still directional light. The lightest part of the sky (where the sun has just set) will cast more ambient light onto the west face of objects in the scene than will be picked up by the east side.

Camera: Canon EOS 1Ds MkII
Lens: 50mm lens
Exposure: 4 sec. at f/18
ISO: 800

IN THE CITY

The urban landscape is a fruitful place to find inspiration for your HDR images. This is particularly true in the winter months before Christmas when lights are often festooned around public spaces. If you live in the colder latitudes, be prepared to swap batteries around frequently as the combination of cold and the need to shoot longer exposures will quickly drain them of power.

Architecture

Architecture can be a wonderfully satisfying subject for photography. The range of shapes, styles, and materials used offer a wealth of interesting opportunities, and a creative approach can yield some terrific images.

Large and small

There is no one right approach to architectural photography, and only you can decide on the tone you wish to set, and the "story" you wish to tell. Do you want to stand back from the building and see it in its surroundings, setting it in its context, or would it be more interesting to home in on a tiny detail?

Before you set up your tripod, it can be useful to walk around your subject and consider it from different points of view, distances, and angles. The longer you look, the more things you are likely to notice. You may find that a particular detail catches you eye, or you might decide that you would like to get your camera down low to give a sense of the grandeur of a building.

Lens choice

Having settled on your preferred composition, you will need to consider which lens to use for best effect. Most buildings are very geometric and you will probably want to retain their straight lines and angles in your images. This can present a challenge, however, especially with a wide-angle lens: the wider the lens you

STACKED
Using longer focal length lenses helps minimize distortion, but can lead to a "busy," stacked look.

Canon EOS 7D with 70–200mm lens (at 200mm), 1/160 sec. at f/7.1, ISO 100

use, the more chance straight lines have of suffering from distortion, which is probably not what you or the architect were striving for.

Whenever possible, use the longest focal length you can, and try to avoid tipping the camera back from a vertical position: if your camera is not parallel to the building you are photographing, you may well introduce an effect known as "converging verticals," where the building will appear to be leaning backward.

However, photography sometimes involves breaking the rules, and tipping your camera over slightly can lead to distinctive and dramatic images. It is all a matter of degree and personal taste. Taking only a small risk with your shot may result in an image that gives the impression of a mistake having been made, whilst being bold with an unconventional composition can result in a more interesting image.

Light

As with any subject you choose to photograph, architecture benefits greatly from attractive light, and giving consideration to how your subject is lit will result in more successful images. You might find a map and compass useful in helping you to predict the times of day that your subject will be best-lit, so you can plan your shoot effectively.

The time of day will influence the quality of the light, as well as its direction. Generally speaking, the light at either end of the day— first thing in the morning, and late afternoon— will be softer than it is at midday and, with favorable weather, it might also cast a pleasing warm glow across brick and stone. Conversely, bright sunlight means harsh shadows and sharp contrast, so be sure to set your bracketing range to make sure that detail is captured in both the shadows and in the highlights.

CONVERGE
For this image I deliberately shot looking upward, using a wide-angle lens to emphasize the height of the subject.

Canon EOS 7D with 17–40mm lens (at 40mm), 1/60 sec. at f/10, ISO 100

Modern buildings will often benefit from hard light and deep shadows, which will serve to emphasize their sharp lines and smart finishes. They may still present challenges, though. For instance, glass façades can be a problem if the sun is shining directly onto them, although a polarizing filter can help to cut down some of this glare.

Glass can also present some very interesting possibilities. Besides being an element of the building itself: consider the buildings, objects, or people that might be reflected in the glass, and this can open up huge potential for exciting image making.

If a building is floodlit, shooting it at night can add tremendous atmosphere to your photos. The key here is to shoot when there is still a small amount of light in the sky—if you wait until the sky is completely dark your subject may be lost against a black background. Around half an hour after sunset is generally good, although it is best to make sure that you are set up and ready well in advance. Light levels will be very low by this point, so a tripod or other steady support will be crucial for sharp images.

DETAILS
Small details can be just as effective at telling the story of a building as shots of the building itself.

Canon EOS 7D with 50mm lens, 1/6 sec. at f/2.2, ISO 250

People

Ultimately, a building will be used by people, so it makes sense to create photos that have the "human touch." Adding people to your architectural images can help to convey a sense of scale, liveliness, and context, but you may not always wish to include people in your shot. If people are milling around this can make an HDR merge more difficult, and you may well have to spend a lot of time removing "ghosts."

One solution is to shoot early in the morning before anyone arrives, although this can be difficult in the depths of winter when people may already be going about their business before it is light! Fortunately, low light levels mean longer shutter speeds, and if your shutter speed is longer than a few seconds then anyone who moves through the shot will be invisible in the resulting image.

INTERIORS
Church interiors often have very subdued lighting, with windows that are brightly backlit. This is a perfect combination for HDR. Tripods are often a must, but you should seek permission before using one: some churches have precious flooring that could be scratched by a tripod.

Canon EOS 7D with 17–40mm lens (at 17mm), three blended images at f/11, ISO 800

Camera: Canon EOS 5D
Lens: 24mm lens
Exposure: Two blended images at f/11
ISO: 100

VERTICAL

The Sage Gateshead, in northeast England, is a strikingly modern building constructed of steel and glass. I wanted to emphasize the curved nature of its design, and a wide-angle lens helped me achieve this. I opted to convert the image to black and white as I felt that color distracted from the architectural form.

Camera: Canon EOS 1Ds MkII
Lens: 24mm lens
Exposure: Three blended images at f/16
ISO: 100

INTERIORS

Shooting inside a building often means working in a small space. This invariably requires the use of a wide-angle lens. Unless you're shooting at an unusual angle for effect, you will need to take care to get your camera level, both horizontally and vertically, to avoid "converging verticals."

Camera: Canon Powershot G10
Lens: 6.1–30.5mm lens
(at 8.1mm)
Exposure: Three blended
images at f/3.2
ISO: 80

KEEPING STEADY

It's rare to be allowed to use a tripod in a busy public building, which obviously makes life more difficult for the HDR shooter. One solution is to use elements of the building as support—I carry a beanbag that can be placed on low walls or tables, for example. Nestling my camera on the beanbag makes a surprisingly stable platform from which to shoot multiple exposures. The key is not to touch the camera between exposures, so using the self-timer and automatic exposure bracketing is a must.

Camera: Canon EOS 1Ds MkII
Lens: 70–200mm lens
(at 100mm)
Exposure: Four blended
images at f/14
ISO: 100

COLOR

When processing your HDR images, try to do it in a way that is sympathetic to your subject. This interior was a riot of color, so I felt a highly saturated approach to the image would help convey something of the atmosphere of the building.

Portraiture

In 1839, Robert Cornelius, a Dutch-born chemist from Philadelphia, made history: he took a photograph of himself, and in doing so created the earliest known photographic portrait.

People have been photographing each other ever since, and whether their shots are formal, informal, or candid, portraits can be a valuable record of family, friendships, and personal history, hence their enduring popularity.

Photographic portraiture today is nowhere near the fraught process it once was. In the 19th century long exposure times required the subject's head to be clamped in place to prevent movement, but today anyone with a little knowledge of portrait techniques can create great images.

Approaching portrait photography

In recent years there has been a move away from the more formal, "posed" portrait style, to a more relaxed and informal one. It is arguably easier to get effective portraits in this way, because the key to making a good portrait image is to make sure that your subject is relaxed. An unhurried and friendly approach to your photography session is therefore critical for successful portraits. This will help to create an informal atmosphere in which you are much more likely to capture your subject at their best.

One way of making really successful portrait images is to take them candidly, so that your subject is completely at ease. You might find it

LONG LENS
Most of my portraits are taken with a 70–200mm zoom lens. I prefer the flatter perspective this lens gives and the fact that I can step back from my subject. This is Canon's 70–200mm f/2.8L lens.

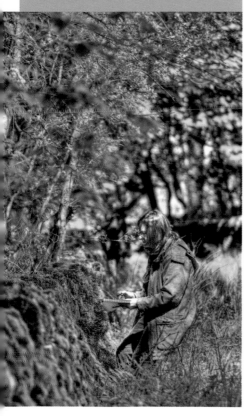

easier to use a longer focal length and move further away from your subject, thus making your presence less obvious and allowing your subject to behave naturally. In this situation, shutter speed will be something you need to take into account: if your subject is not "posed" for your shot and is moving around, a faster shutter speed will be necessary to minimize any motion blur.

Another advantage of using a longer focal length is that the perspective is more flattering because you need to step back from your subject. If you fill the frame with a face using a wide-angle lens and the nose becomes far too prominent, the other facial features will seem distorted. Using a wide-angle lens this way will not endear you to your subject.

Photographing children

Children are popular subjects for portrait photography, and good photographs of them can create a precious record of their early years. They are not always the easiest of subjects (or the most cooperative), but they do tend to be less guarded and more spontaneous than adults, which means photographing them effectively can lead to very satisfying results.

The key to photographing children is that they should be relaxed, and that the experience should be enjoyable for them. It can be easier to photograph them in an environment that is familiar to them, or to do your photo shoot in a place where they can have fun—a park or a zoo, for example.

There are numerous approaches you might adopt regarding the style of the resulting photograph, which will depend on the setting, the child's personality, and so on. A soft, high-key image will help to convey a feeling of lightness and innocence, while a high-contrast, grainier photograph might better convey the personality of a more mischievous child.

Using flash

Photography is all about light, and getting your lighting right is vital with portrait photography, especially in a more formal setting. The least flattering light you can use in portraiture is a flash unit attached to your camera's hotshoe. The light will be fired directly at your subject, and the resulting image can look harsh and artificial. The effect can be softened by using a diffuser on your flash, or by bouncing the light off a ceiling or wall—both will help to create a softer, more natural-looking light.

Where flash comes into its own in portraiture is as a fill-in light. This is particularly useful outdoors, especially when the sun is behind your subject and their face is in danger of being underexposed. Use of fill-flash helps to balance out this harsh contrast and create a more pleasing image.

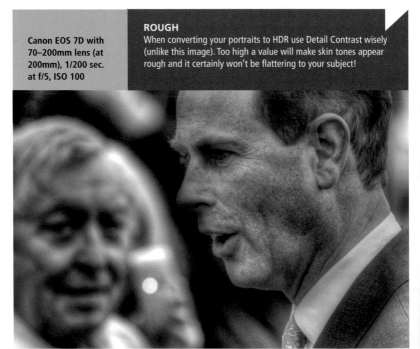

Canon EOS 7D with 70–200mm lens (at 200mm), 1/200 sec. at f/5, ISO 100

ROUGH
When converting your portraits to HDR use Detail Contrast wisely (unlike this image). Too high a value will make skin tones appear rough and it certainly won't be flattering to your subject!

Social occasions

Although most people don't like to have their picture taken, for some reason those inhibitions are lessened at social occasions. This is particularly true at events such as weddings, when people are dressed up and looking their best. To make the most of these occasions arrive long before the event starts so that you can familiarize yourself with the surroundings. Look for places that would make a good background for your subjects and if there is an itinerary make sure you have a copy so you know the times of particular events. If the event is spread over a wide area, work out the shortest routes between places beforehand.

While photographing an event, try to minimize lens changes. It's too easy to miss something important if you're rummaging around in your camera bag, so pick a zoom lens with a good focal length range (wide-angle to short telephoto is ideal) and work with that. If using flash would be frowned upon (which would apply to weddings in particular), be prepared to increase your camera's ISO setting. Alternatively, a prime lens with a wide maximum aperture is very useful here.

A good motto when photographing social occasions is "be prepared." Before the day itself try to work through every eventuality. Carry spares of items such as batteries and memory cards, and if you have a second camera body take that along also—it's better to have the equipment with you and not use it, than to find you left something essential at home.

MOVEMENT

Events where people are moving around quickly invariably mean it's difficult to shoot multiple exposures. If you need to shoot single exposures to create single-shot HDR images, keep an eye on your camera's histogram to optimize the exposure.

Canon EOS 7D with 17–40mm lens (at 200mm), 1/40 sec. at f/11, ISO 250

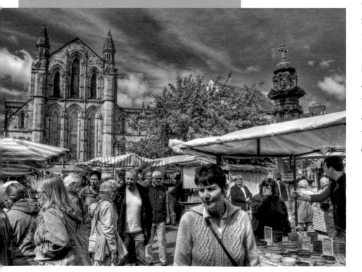

Attracting attention

A person in a picture has a lot of "visual weight." Even when the person is relatively small in an image they immediately grab your attention. This can be accentuated by using lines and objects in your subject's surroundings that point toward them.

Camera: Canon EOS 1Ds
Lens: 24mm lens
Exposure: 1/200 sec. at f/11
ISO: 100

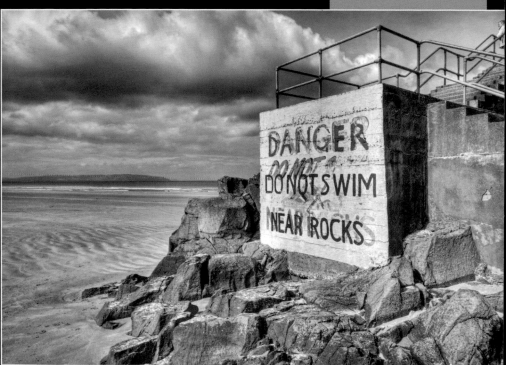

A person's possessions are a reflection of their personality. When shooting portraits ask your sitter if they would be willing to hold something that they own that is precious to them. This also, rather neatly, will give your subject something to do with their hands.

Camera: Canon EOS 5D
Lens: 50mm lens
Exposure: 1/60 sec. at f/11
ISO: 400

Glossary

Aberration An imperfection in a photograph, often caused by the optics of a lens.

AE (autoexposure) lock A camera control that locks in the exposure value, allowing a scene to be recomposed prior to the shot being taken.

Angle of view The area of a scene that a lens views, measured in degrees.

Aperture The opening in a camera lens through which light passes to expose the sensor. The relative size of the aperture is denoted by f-stops.

Autofocus (AF) A reliable through-the-lens focusing system that allows accurate focusing without the user manually adjusting the lens.

Bracketing Taking a series of identical pictures, changing only one setting, such as the exposure or white balance.

Buffer A digital camera's built-in memory.

Cable release A device used to trigger the shutter of a tripod-mounted camera at a distance to avoid camera shake.

Calibrator A device used to measure the output of digital imaging equipment. A profile will then be created that can be used by other equipment to keep colors consistent.

Center-weighted metering A metering pattern that determines the exposure of a scene with a bias toward the center of the frame.

Chromatic aberration The inability of a lens to bring all spectrum colors into focus at one point, resulting in color fringing.

Color temperature The color of a light source expressed in degrees Kelvin (K).

Codec A piece of software used to interpret and decode a digital file, such as RAW.

Compression The process by which digital files are reduced in size.

Contrast The range between the highlight and shadow areas of a photo, or a marked difference in illumination between colors or adjacent areas.

Depth of field (DoF) The amount of a photograph that appears acceptably sharp. This is controlled by the aperture: the smaller the aperture, the greater the depth of field.

DPOF Digital Print Order Format.

Diopter Unit expressing the power of a lens.

dpi (dots per inch) Measure of the resolution of a printer or scanner. The more dots per inch, the higher the resolution.

Dynamic range The ratio between the brightest and darkest parts of a scene. Also used to describe a camera sensor's ability to capture a full range of shadows and highlights.

Evaluative metering A metering system where light reflected from several subject areas is

calculated based on algorithms. Also known as Matrix or Multi-segment metering.

Exposure The amount of light allowed to reach the digital sensor, controlled by aperture, shutter speed, and ISO. Also, the act of taking a photograph, as in "making an exposure."

Exposure compensation A control that allows intentional over- or underexposure.

Extension tubes Hollow spacers that fit between a camera body and lens, typically used for close-up work. The tubes increase the focal length of the lens and magnify the subject.

Fill-in flash Flash combined with daylight in an exposure. Used with naturally backlit or harshly side-lit or top-lit subjects to prevent silhouettes forming, or to add extra light to the shadow areas of a well-lit scene.

Filter A piece of colored, or coated glass or plastic placed in front of the lens.

Focal length The distance (usually given in millimeters) from the optical center of a lens to its focal point.

fps (frames per second) A measure of the time needed for a digital camera to process one photograph and be ready to shoot the next.

f-stop Number assigned to a particular lens aperture. Wide apertures are denoted by small numbers such as f/2, and small apertures by large numbers such as f/22.

HDR High Dynamic Range; a technique to increase the tonal range of a photo by merging several photographs shot with different exposure settings.

Histogram A graph used to represent the distribution of tones in a photograph.

Hotshoe An accessory shoe with electrical contacts that allows synchronization between the camera and a flash unit.

Hotspot A light area with a loss of detail. A common problem in flash photography.

Incident-light reading Meter reading based on the light falling on the subject.

Interpolation A means of increasing the size of a digital photo by adding pixels, thereby increasing its resolution.

ISO (International Organization for Standardization) The sensitivity of the digital sensor measured in terms equivalent to the ISO rating of film.

JPEG (Joint Photographic Experts Group) A compressed file format that uses lossy compression to reduce file sizes to about 5% of their original size.

LCD (Liquid Crystal Display) The flat screen on a digital camera that allows the user to preview and review photographs.

Macro A term used to describe close focusing and the close-focusing ability of a lens.

Megapixel One megapixel = one million pixels.

Memory card A removable storage device for digital cameras.

Mirror lock-up A function that allows the reflex mirror of an SLR camera to be raised and held in the "up" position, before the exposure is made.

Noise Interference visible in a photo caused by stray electrical signals during exposure.

Open-Source Software created by unpaid volunteers that is often free to use.

PictBridge The industry standard for sending information directly from a camera to a printer, without having to connect to a computer.

Pixel Short for "picture element"—the smallest bit of information in a digital photograph.

RAW The file format in which the raw data from the sensor is stored without permanent alteration being made.

Red-eye reduction A system that causes the pupils of a subject to shrink by shining a light prior to taking the picture.

Resolution The number of pixels used to capture or display a photo.

RGB (Red, Green, Blue) Computers and other digital devices understand color information as combinations of red, green, and blue.

Rule of thirds A rule of thumb that places the key elements of a picture at points along imagined lines that divide the frame into thirds, both vertically and horizontally.

Shutter The mechanism that controls the amount of light reaching the sensor.

SLR (Single Lens Reflex) A type of camera that allows the user to view the scene through the lens, using a reflex mirror.

Soft proofing Using software to mimic on screen how an image will look once output to another imaging device. Typically, this will be a printer.

Spot metering A metering system that places importance on the intensity of light reflected by a very small portion of the scene.

Teleconverter A lens that is inserted between the camera body and the main lens, increasing the effective focal length.

Telephoto A lens with a long focal length and a narrow angle of view.

TTL (Through The Lens) A metering (or other) system built into the camera that measures the light passing through the lens.

White balance A function that allows the correct color balance to be recorded for any given lighting situation.

Wide-angle lens A lens with a short focal length and a wide angle of view.

Useful web sites

GENERAL

Digital Photography Review
Camera and lens review web site
www.dpreview.com

Flickr
Photo sharing web site with a large user base
www.flickr.com

David Taylor
Landscape and travel photography
www.davidtaylorphotography.co.uk

Luminous Landscape
Comprehensive online guide to photography,
including HDR
www.luminous-landscape.com

EQUIPMENT

Adobe
Photographic editing software including
Photoshop and Lightroom (Mac/Windows)
www.adobe.com

Bracketeer
Simple tone mapping software (Mac only)
www.pangeasoft.net

Everimaging
Developers of HDR Photo Pro and
HDR Darkroom (Windows only)
www.everimaging.com

FDRTools
Tone mapping software (Mac/Windows)
www.fdrtools.com

Fhotoroom
Image-editing software with tone mapping
controls (Windows only)
www.fhotoroom.com

HDRsoft
Developers and retailers of Photomatix
(Mac/Windows)
www.hdrsoft.com

PHOTOGRAPHY PUBLICATIONS

**Photography books & Expanded
Camera Guides**
www.ammonitepress.com

Black & White Photography magazine
Outdoor Photography magazine
www.thegmcgroup.com

Index

Understanding HDR Photography

APS-C DSLR with 17mm focal length
(approx. 28mm angle of view equivalent)

SUBJECT DISTANCE	f/4		f/5.6		f/8		f/11		f/16	
FEET	Near	Far	Near	Far	Near	Far	Near	Far	Near	Far
100	11.1	∞	8.1	∞	5.9	∞	4.2	∞	3	∞
50	-0	∞	7.5	∞	5.5	∞	4	∞	2.9	∞
25	8.3	∞	6.5	∞	5	∞	3.8	∞	2.8	∞
12	6.1	232	5.1	∞	4.1	127	3.2	∞	2.5	∞
6	4	1.5	3.5	18.4			2.6	9	2	∞
3	2.4	3.9	2.2	4.5	2	5.7	1.8	9	1.5	53.6

SUBJECT DISTANCE	f/4		f/5.6		f/8		f/11		f/16	
METERS	Near	Far	Near	Far	Near	Far	Near	Far	Near	Far
30	3.4	∞	2.5	∞	1.8	∞	1.3	∞	0.92	∞
15	3	∞	2.3	∞	1.7	∞	1.2	∞	0.9	∞
8	2.6	∞	2	∞	1.5	∞	1.1	∞	0.8	∞
4	1.9	∞	1.6	∞	1.3	∞	1	∞	0.77	∞
2	1.3	4.2	1.2	7.6	1	∞	0.8	∞	0.6	∞
1	0.8	1.3	0.7	1.6	0.7	2	0.6	3.7	0.5	∞

APS-C DSLR with 35mm focal length
(approx. 50mm angle of view equivalent)

SUBJECT DISTANCE	f/4		f/5.6		f/8		f/11		f/16	
FEET	Near	Far	Near	Far	Near	Far	Near	Far	Near	Far
100	35	∞	27.2	∞	21	∞	15.8	∞	11.7	∞
50	26	800	21.4	∞	17.3	∞	13.6	∞	10.5	∞
25	-7	47	15	75	13	425	10.7	∞	8.7	∞
12	-0		9.1	18	8.3	22	7.3	33	6.3	119
6	5.4	6.7	5.2	7.1	4.9	7.7	4.6	8.8	4.1	10.8
3	2.8	3.1	2.8	3.2	2.7	3.4	2.6	3.5	2.5	3.8

SUBJECT DISTANCE	f/4		f/5.6		f/8		f/11		f/16	
METERS	Near	Far	Near	Far	Near	Far	Near	Far	Near	Far
30	10.5	∞	8.3	∞	6.4	∞	4.8	∞	3.6	∞
15	7.8	209	6.5	∞	5.2	∞	4.1	∞	3.2	∞
8	5.3	15.8	4.7	26.6	4	684	3.3	∞	2.7	∞
4	3.2	5.3	3	6.1	2.7	7.9	2.3	13.1	2.3	249
2	1.8	2.3	1.7	2.4	1.6	2.6	1.5	3	1.3	3.9
1	0.9	1	0.9	1.1	0.89	1.14	0.9	1.2	0.8	1.3

THE EXPANDED GUIDE

Full-frame DSLR with 28mm focal length

SUBJECT DISTANCE	f/4		f/5.6		f/8		f/11		f/16	
FEET	Near	Far	Near	Far	Near	Far	Near	Far	Near	Far
100	17.7	∞	13.2	∞	9.7	∞	7	∞	5	∞
50	15	∞	11.6	∞	8.8	∞	6.6	∞	4.8	∞
25	11.6	∞	9.5	∞	7.5	∞	5.8	∞	4.4	∞
12	7.7	27	6.7	56	5.7	∞	4.7	∞	3.7	∞
6	4.7	8.3	4.3	9.8	3.9	13.4	3.4	27	2.8	∞
3	2.6	3.5	2.5	3.7	2.3	4.1	2.2	4.9	1.9	6.5

SUBJECT DISTANCE	f/4		f/5.6		f/8		f/11		f/16	
METERS	Near	Far	Near	Far	Near	Far	Near	Far	Near	Far
30	5.4	∞	4	∞	2.9	∞	2.1	∞	1.5	∞
15	4.6	∞	3.5	∞	2.7	∞	2	∞	1.4	∞
8	3.6	∞	2.9	∞	2.3	∞	1.8	∞	1.3	∞
4	2.5	10.2	2.1	28.5	1.8	∞	1.5	∞	1.2	∞
2	1.5	6.6	1.4	3.5	1.2	5	1	13.7	0.9	∞
1	0.9	1.2	0.8	1.3	0.77	1.4	0.7	1.7	0.6	2.5

Full-frame DSLR with 50mm focal length

SUBJECT DISTANCE	f/4		f/5.6		f/8		f/11		f/16	
FEET	Near	Far	Near	Far	Near	Far	Near	Far	Near	Far
100	40.6	∞	32.6	∞	25.5	∞	19.5	∞	14.6	∞
50	28.9	185	24.6	∞	20.3	∞	16.3	∞	12.8	∞
25	18.3	39.3	16.5	51.4	14.5	91.5	12.3	∞	10.2	∞
12	10.2	14.5	9.6	15.9	8.9	18.4	8	23.5	7	39
6	5.5	6.6	5.3	6.8	5.1	7.2	4.8	7.9	4.5	9.1
3	2.9	3.1	2.8	3.2	2.8	3.3	2.7	3.4	2.6	3.6

SUBJECT DISTANCE	f/4		f/5.6		f/8		f/11		f/16	
METERS	Near	Far	Near	Far	Near	Far	Near	Far	Near	Far
30	12.3	∞	9.9	∞	7.7	∞	5.9	∞	4.4	∞
15	8.7	53	7.4	∞	6.2	∞	4.9	∞	3.8	∞
8	5.8	17.4	5.2	17.4	4.5	33.8	3.8	∞	3.1	∞
4	3.4	4.9	3.1	5.5	2.9	6.4	2.6	8.6	2.9	16.6
2	1.8	2.2	1.77	2.3	1.7	2.5	1.6	2.7	1.5	3.2
1	0.96	1.05	0.94	1.07	0.92	1.1	1.9	1.15	0.8	1.2

PHOTOGRAPHER'S
GRAY CARD

CAMERA RAW
WHITE BALANCE